The wheel bears no resemblance to a leg

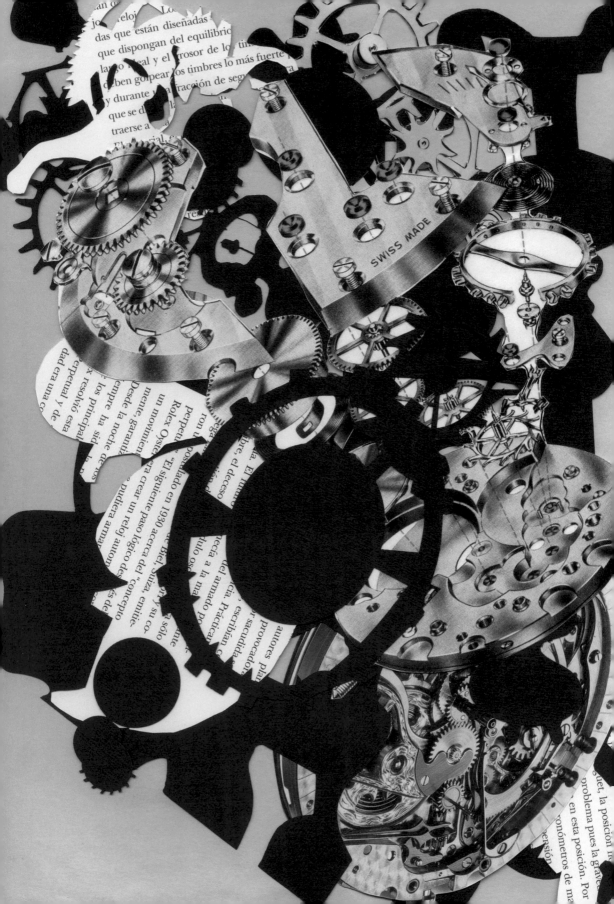

The wheel bears no resemblance to a leg

Erick Meyenberg

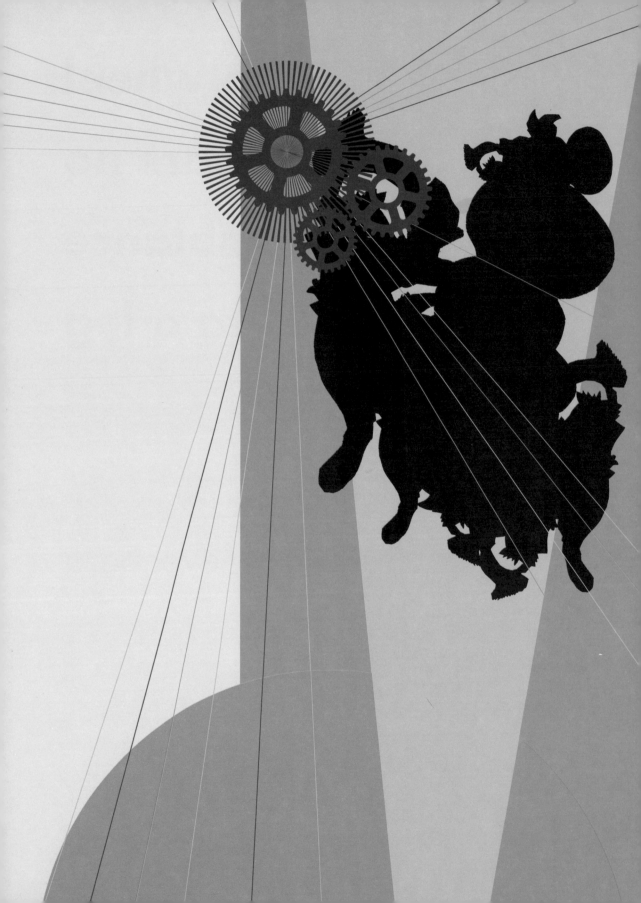

Quand l'homme a voulu imiter
la marche, il a crée la roue qui
ne ressemble pas à une jambe.
Il a fait ainsi du surréalime sans
le savoir.

When man wanted to imitate
walking, he created the wheel,
which bears no resemblance to
a leg. In this way he engaged in
surrealism without knowing it.

—Guillaume Apollinaire

...ciar mejor sus
ble tener una pizca de
básicos, los que ayudan
e jamás

perpetual y de
lex resolvió esta
de los principa
siempre ha sid
Desde la noche de los
mente, garantiz
un movimient
Rolex Oyster
ron u
perpetu "El siguiente paso lógico des
lega Emil Boren, oriundo de Biel, Suiza, emitie
una cuestión de tiempo, Hans Wilsdorf y su co-
sólo el deceso del péndulo oscilatorio era
libre, el futuro pertenecía a la masa oscilante
a. El futuro seguía hablando del armado por sacu-
die seguía hablando de la experiencia. Prácticamen-
pajel? En 1945, escribían con
de armado por sacudida ser
unta realmente provocadora:
m de Rolex. Sus autores plan-
eich escribía estas
os del siglo XX. Los pri
dos en series limitadas ac
en series limitadas po
manufacturas suizas po
los relojeros a un
rospectiva que plan
dudas que plan
quel entonc
los
ntos pequeños
ilindro no po
mientos más
se alberga
olsillo.
sas fueron cambian-
décadas. En la actuali-
es modernos soportan
humedad, y los avances
la balanza a favor del
interno del tictac.
por los cambios
gnéticos, los con

a apreciar la
conocimien
esfuerzos,
a apreciar más

reloj de p
eche cuando

proezas de hoy, sin emba
res deportistas mecánico
cuando el muelle
tementeso, o cuando sus
lsera seguirá f
que sus roda
su tictac continuara
go, el motor de un aut
estuviese expuesto a una situación si
casez de lubricante, se destruiría
movimiento mecánico de un ro
fiere del motor de un automóvil en o
tradicionalmente, el primero funciona c
24 horas sin parar, mientras que el segund
se usa durante algunas horas sucesivas.

Estas son sólo algunas de las extraordinaria
por las que a pesar de la ra
dad de relojes electrónicos ultramodernos
NASA y otras agencias espaciales se
al espacio a astronautas equipa
mecánicos convencional

Mode d'emploi

Erick Meyenberg's *The wheel bears no resemblance to a leg* [La rueda no se parece a una pierna, 2016] is a large-scale art project that attests to an important shift toward interdisciplinary thinking in contemporary art practices shaped by site-specificity and relational aesthetics. This publication aims to document the different stages of the two-year collaboration between Meyenberg and members of the high school marching band Banda de Guerra Lobos at the Colegio Hispanoamericano in Mexico City. The artist and the teenagers—together with teachers, curators, musicians, composers, choreographers, costume designers, and a video production team—co-created choreographies, musical scores, and a series of performances that took the band through some of the city's most emblematic and politically marked sites: the Plaza de Tlatelolco, where striking university students clashed with the state in 1968; the Monumento a la Revolución, commemorating the Mexican Revolution of 1910; and the Forum Buenavista shopping center, symbolizing Mexico's embeddedness in transnational, post-industrial capitalism.

Meyenberg takes his enigmatic title from the prologue to Guillaume Apollinaire's satirical play *Les mamelles de Tirésias* [The Breasts of Tiresias]. Significantly, it is in this text where Apollinaire coined the term "surrealism," which later was appropriated by André Breton and disseminated throughout the twentieth century by the surrealists in France and elsewhere. Meyenberg translates disparate sources—sketches, photographs, and video recordings made during the workshops and performances with members of the marching band and other collaborators, as well as machine operation diagrams and art historical texts correlating to early French modernism—and blends these to generate

a critical stance toward normative pedagogical structures—represented here by uniforms, discipline, education, gender, the state, and symbols of nationhood. He also proposes a conception of the "surreal" which is not an evasion of reality, but an invitation to overcome other realities through creativity.

On the one hand, the project examines a clash between Mexican youth and the promise of modernity and social progress advocated by the Revolution and projected through a symbolic itinerary performed by the marching band in Mexico City. On the other hand, it re-creates a machinery of power that propels a historical construct of Mexico as subservient to global modernism. Paralleling Meyenberg's approach, which involves combining, disassembling, and re-articulating an array of methodologies from history, art history, literature, philosophy, design, and political science, this publication gathers various components to create a visual/critical/art historical "machine," echoing the poetic strategy undertaken by the artist for the institutional presentation of his project at Yerba Buena Center for the Arts and Americas Society.

The publication is structured in two sections. The first, visual component is at once a variation of an artist's book and a collection of photos that immerse readers into the performance (or at least into the afterlife of the performance), engaging them as yet another group of collaborators in the creative interaction among Meyenberg, the marching band members, and the other co-participants. This section concludes with a diagram and index created by the artist which maps the multiple functions of pedagogy, representing them as cogs in a machine of power. The second section, comprised of two essays and an interview, provides, among other things, several critical lenses through which to read *The wheel bears no resemblance to a leg*: Osvaldo Sánchez includes both personal and critical ruminations on the implications of the work; Gabriela Rangel's analysis offers art historical, critical, and methodological frameworks for Meyenberg's endeavor; and, Lucía Sanromán's interview with Meyenberg continues the conversation(s) that were integral to the fundamentally collaborative conception and execution of *The wheel bears no resemblance to a leg*, allowing the discourse(s) to continue.

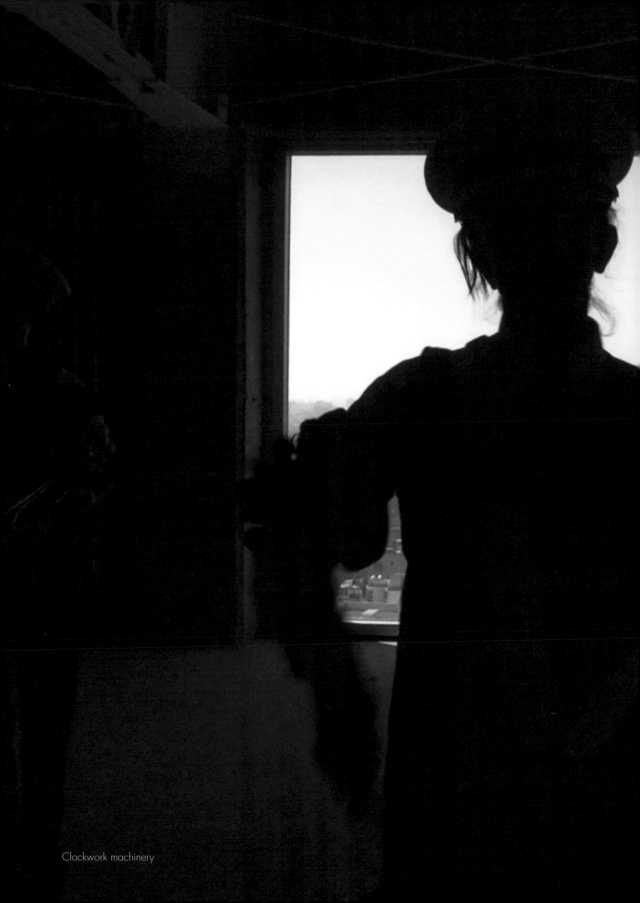

Clockwork machinery

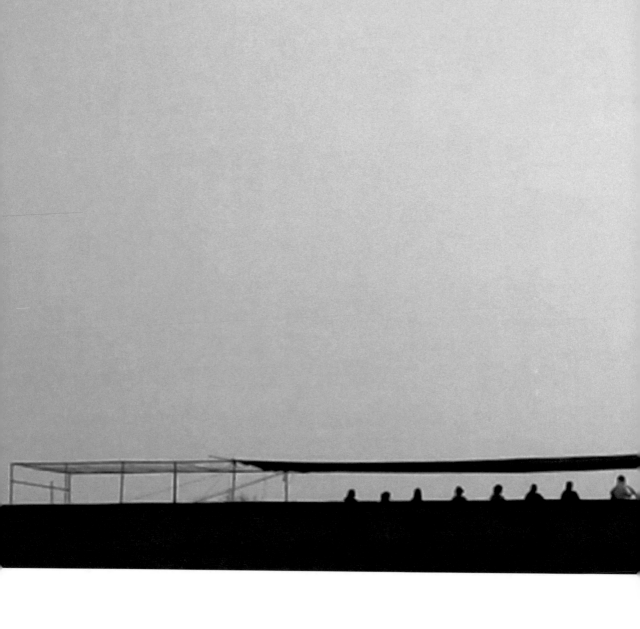

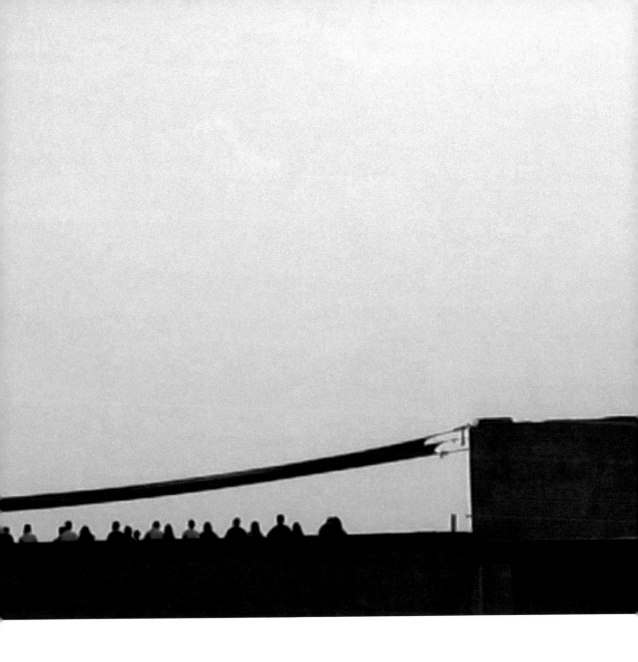

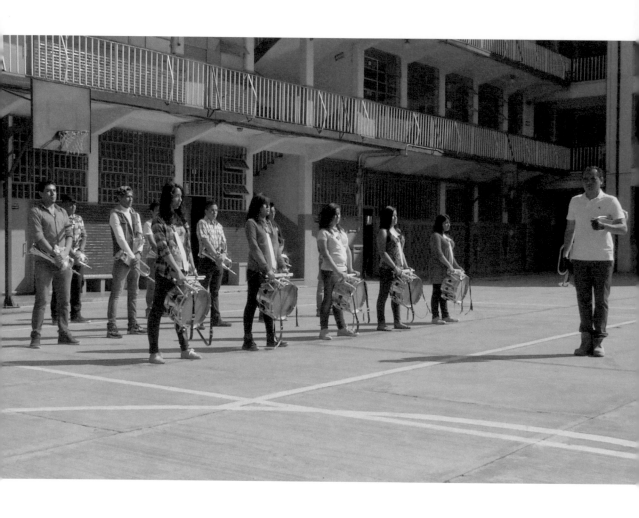

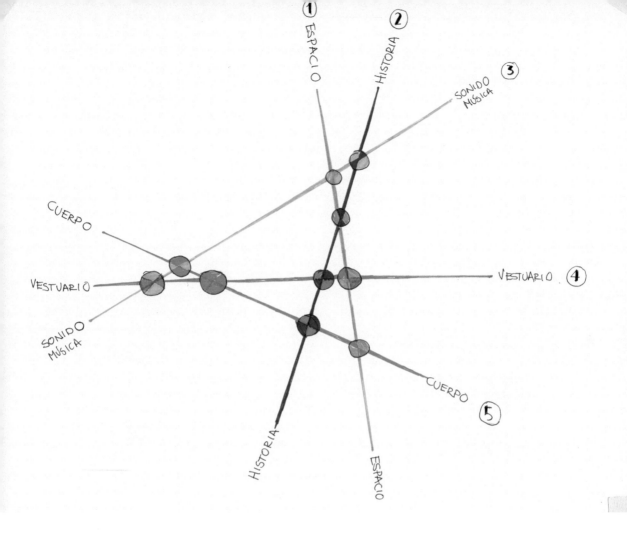

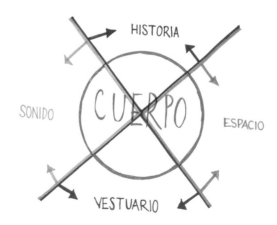

15

ESPACIO

UNIFORME

CUERPO

HISTORIA

SONIDO

Stars: teenage body

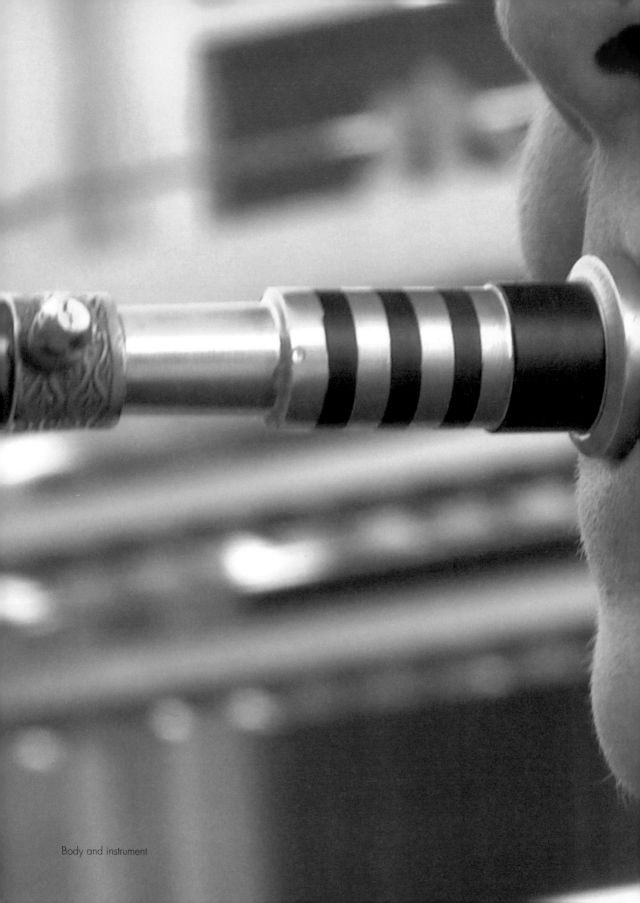

Body and instrument

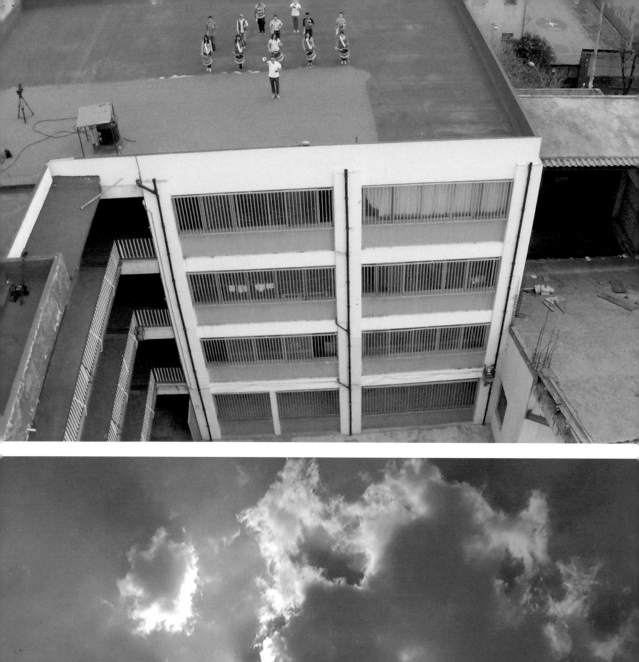

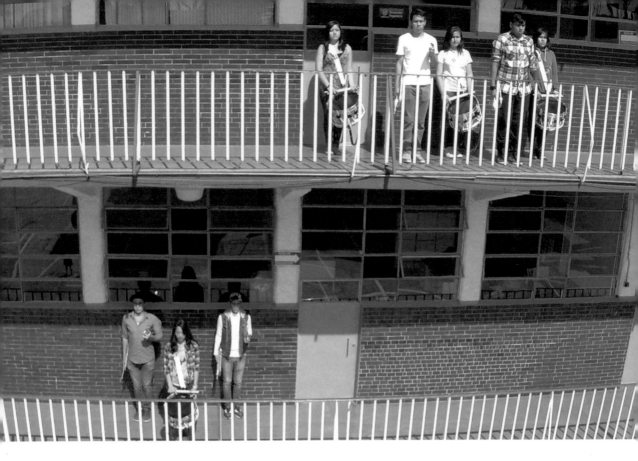

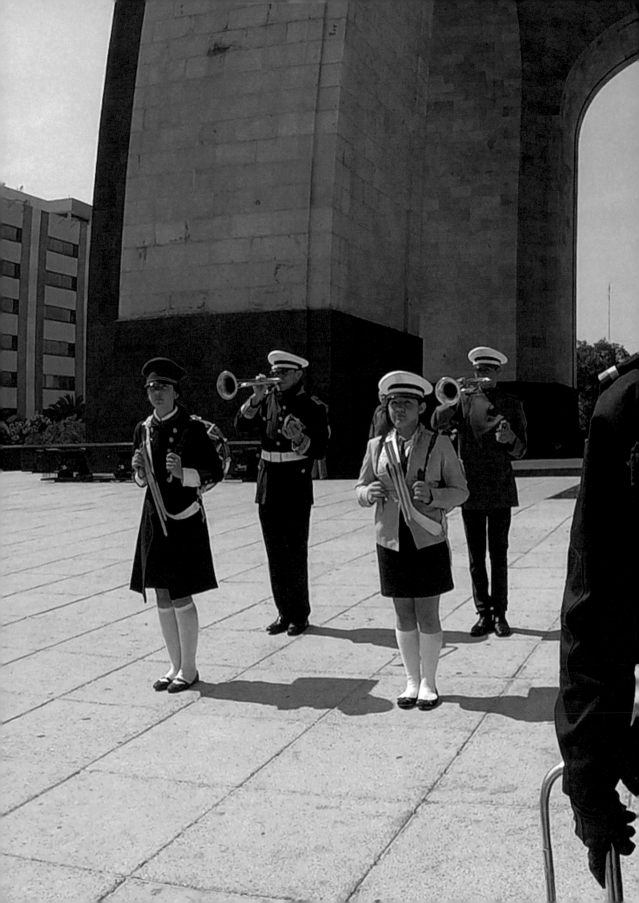

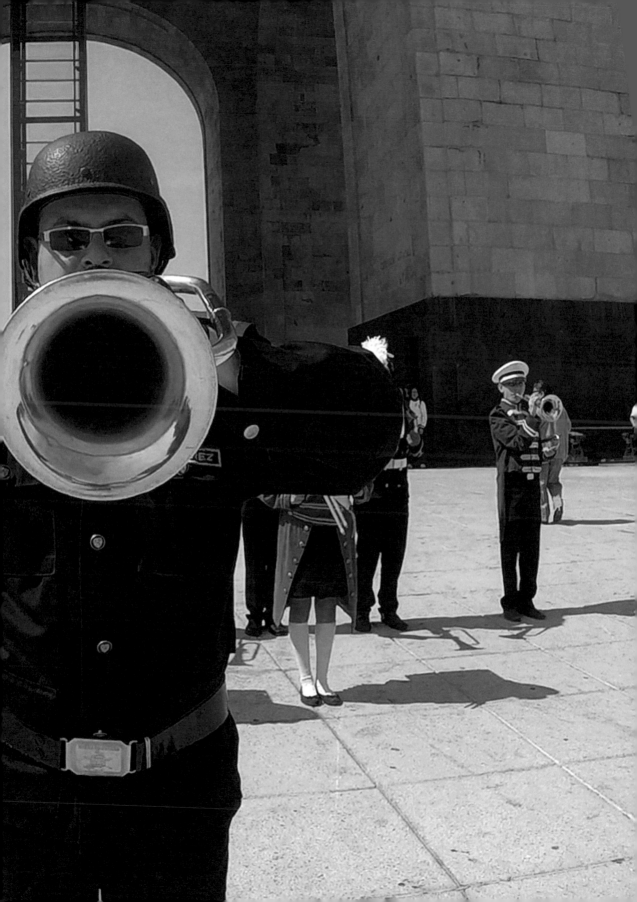

Body and uniform

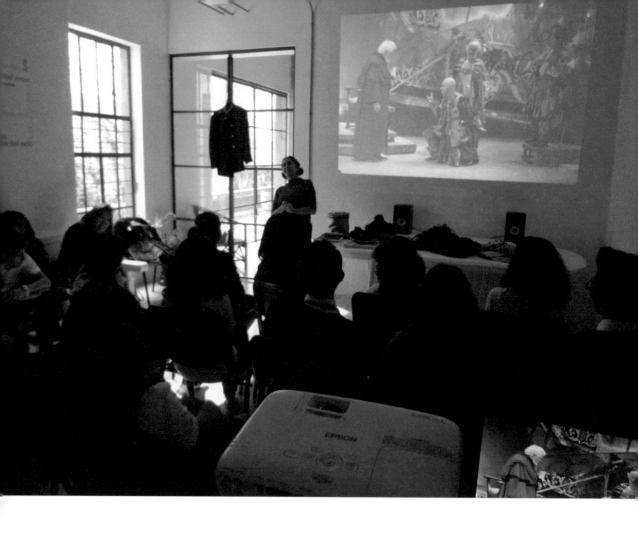

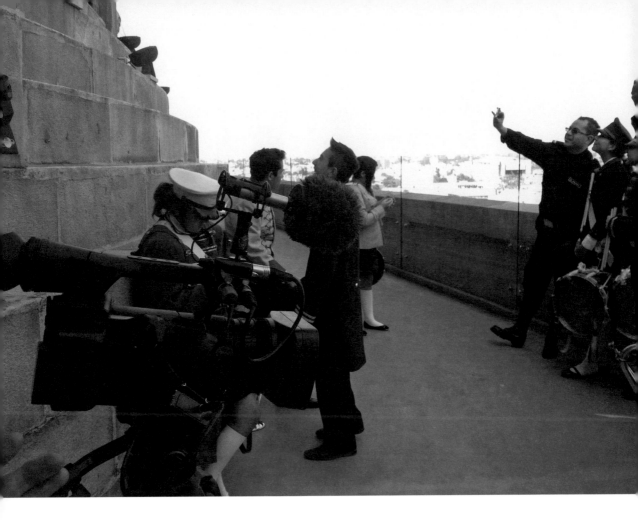

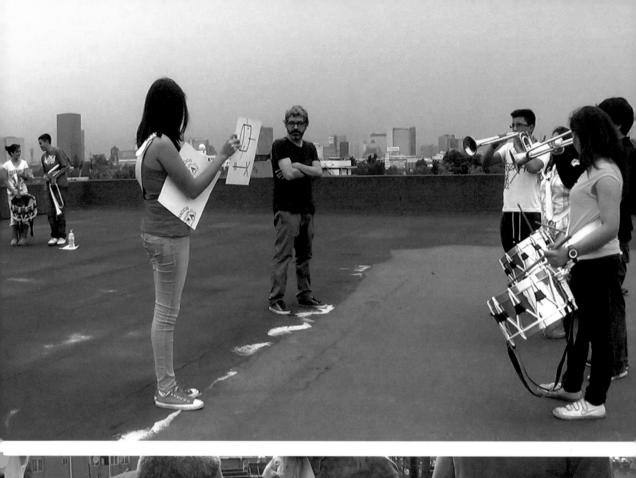

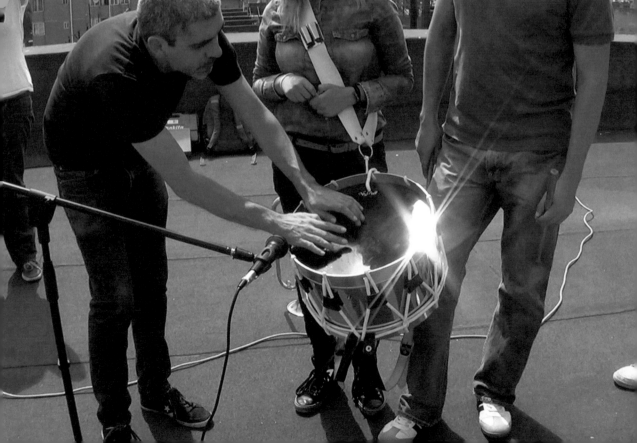

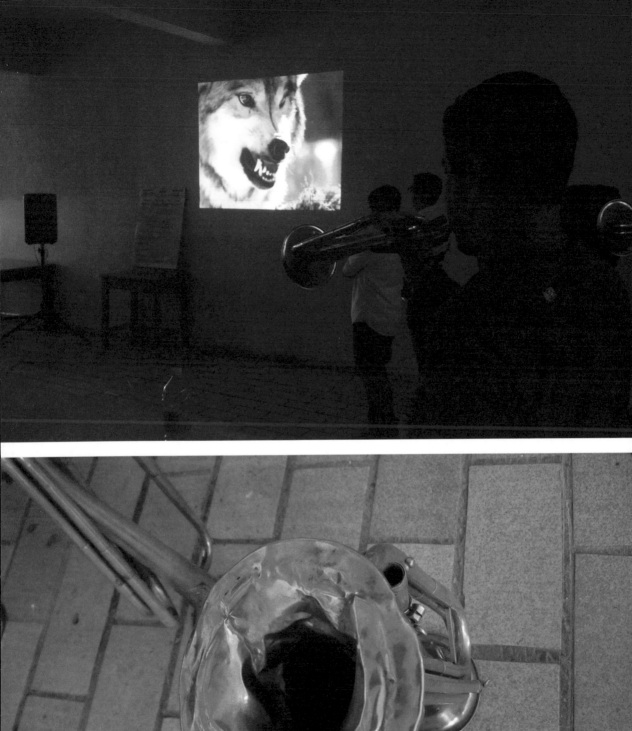

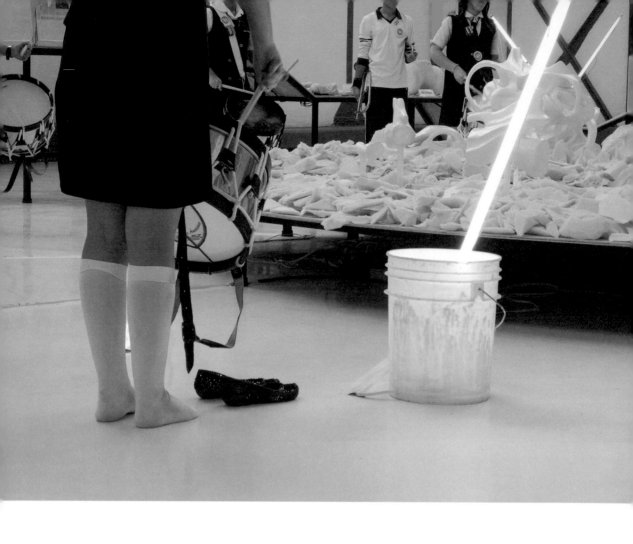

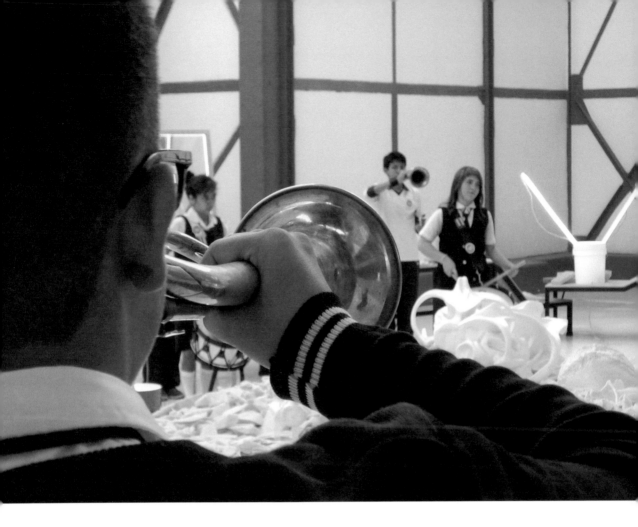

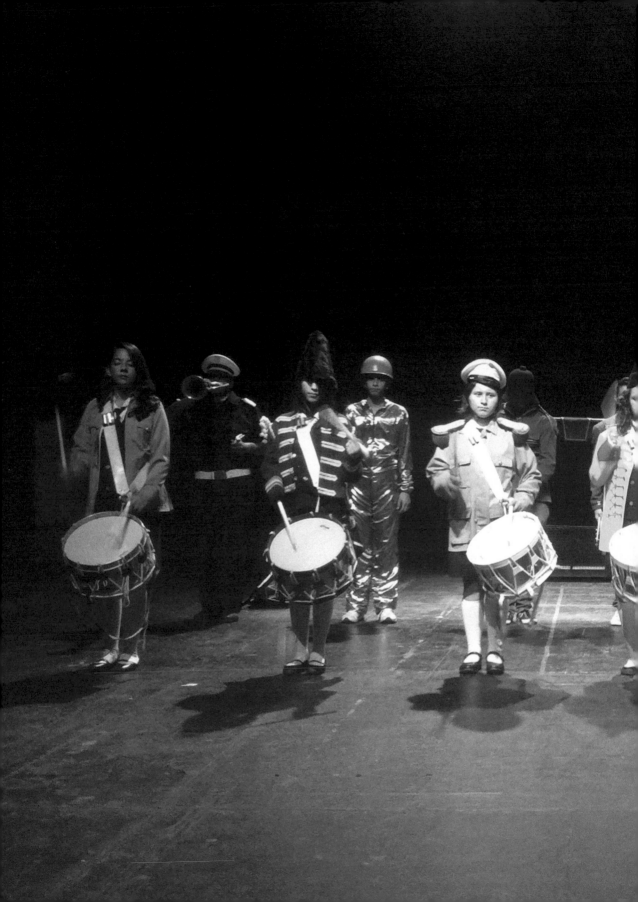

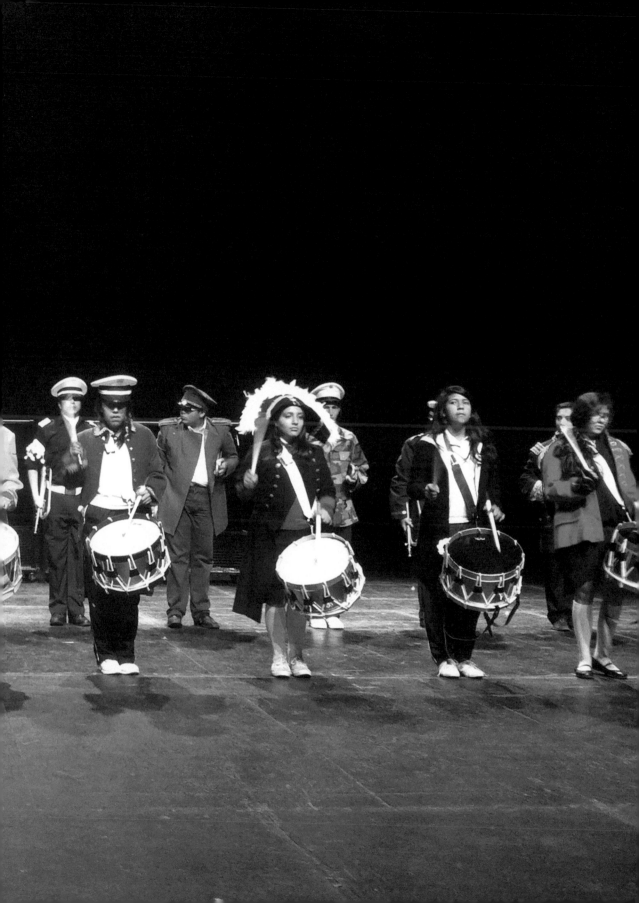

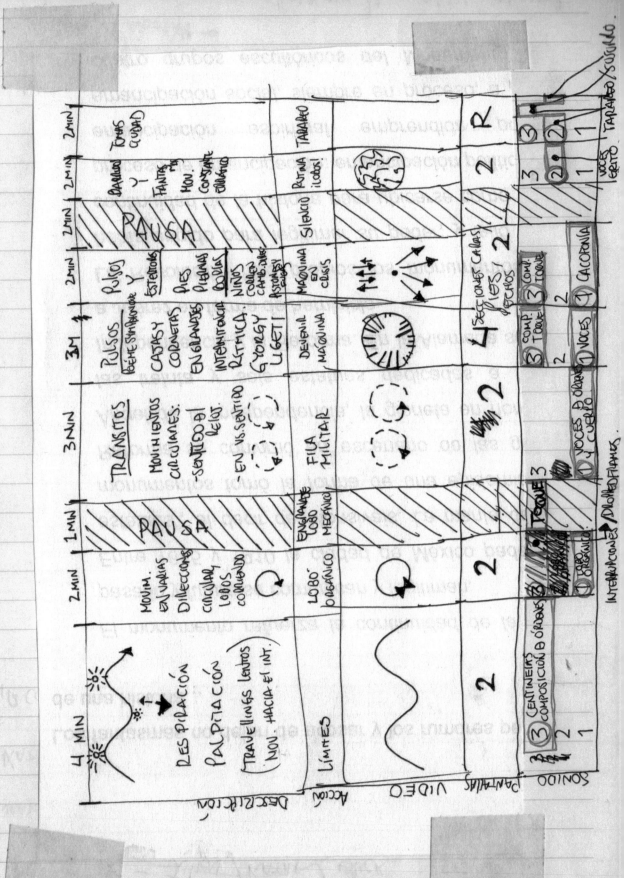

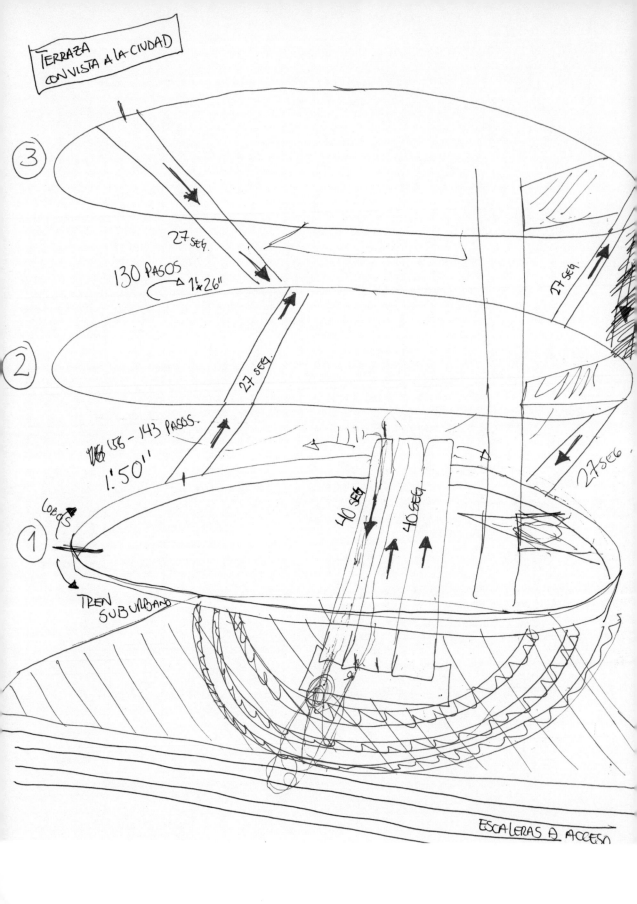

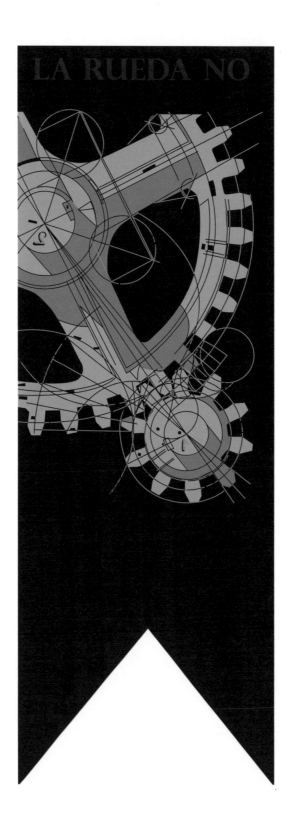

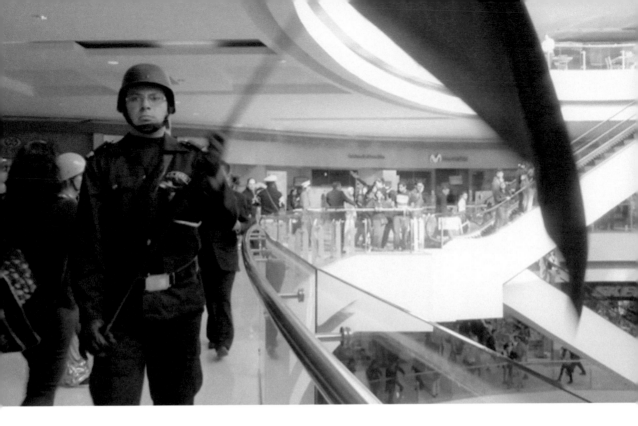

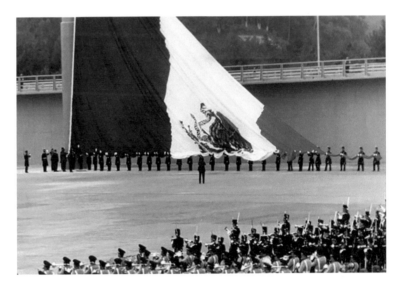

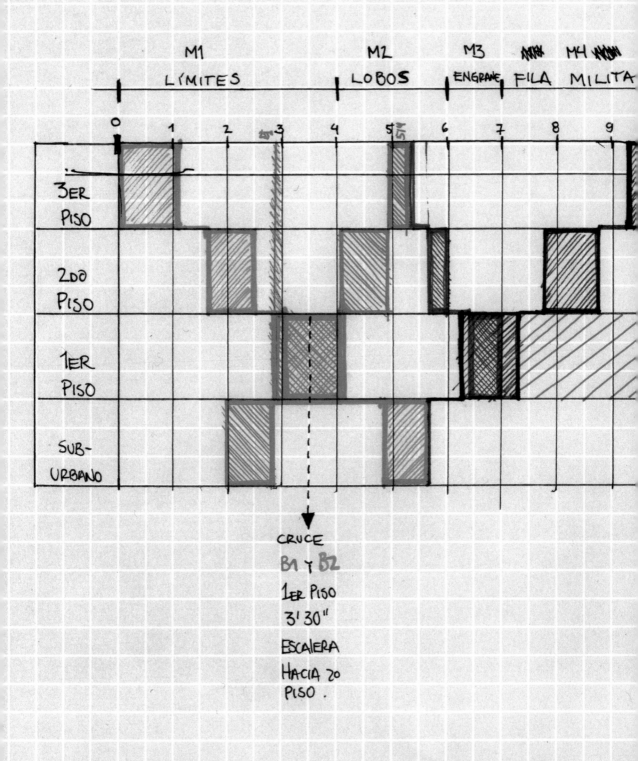

M1 M2 M3 M4

LÍMITES LOBOS ENGRANE FILA MILITA

0 1 2 3 4 5 6 7 8 9

3ER PISO

2DO PISO

1ER PISO

SUB-URBANO

CRUCE

B1 Y B2

1ER PISO

3' 30"

ESCALERA

HACIA 2o

PISO .

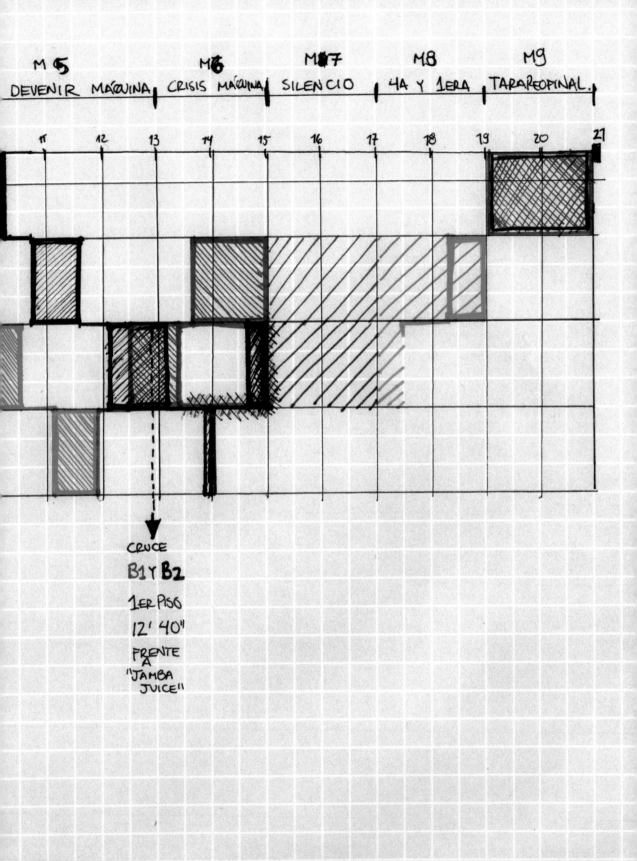

M 5 M 6 M 7 M 8 M 9

DEVENIR MÁQUINA CRISIS MÁQUINA SILENCIO 4A Y 1ERA TARAREOPINAL.

11 12 13 14 15 16 17 18 19 20 21

CRUCE

B1 Y B2

1ER PISO

12' 40"

FRENTE A "JAMBA JUICE"

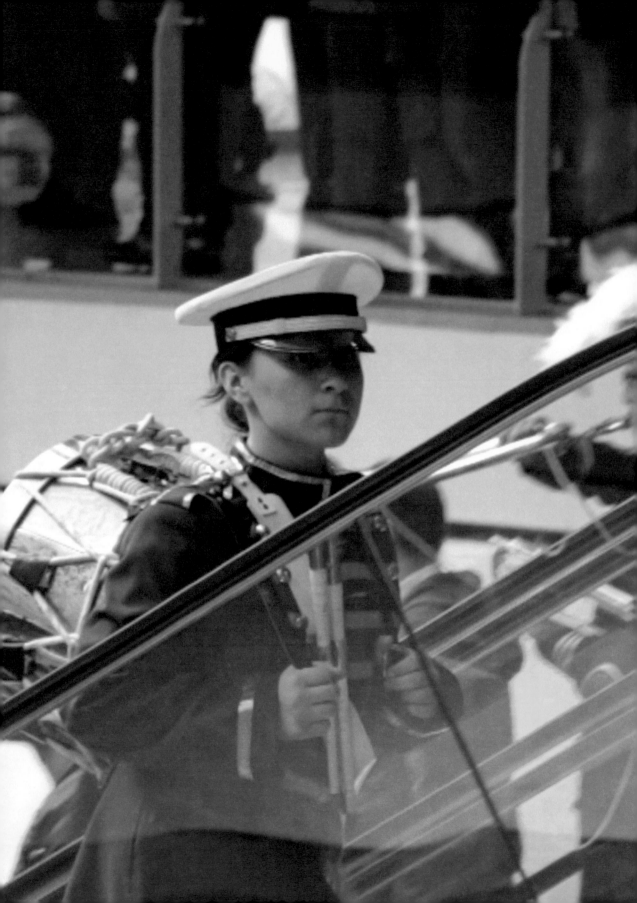

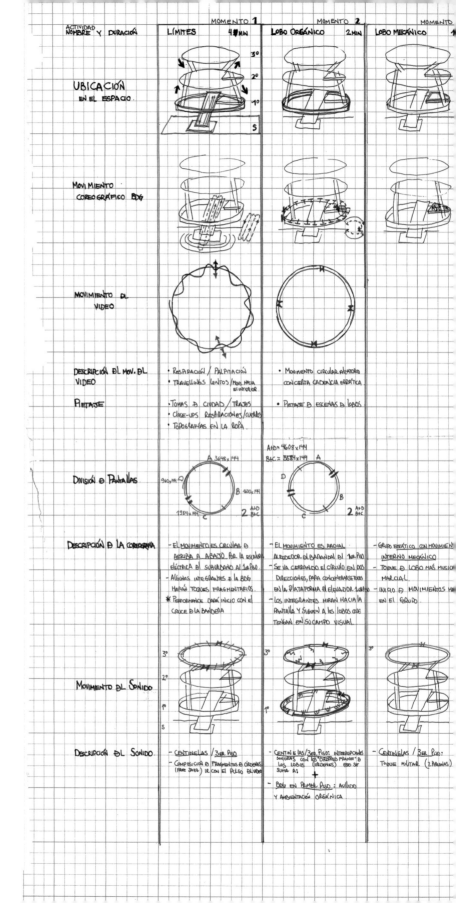

ACTIVIDAD NOMBRE Y DURACIÓN	MOMENTO **1** LÍMITES · 4 MIN	MOMENTO **2** LOBO ORGÁNICO · 2 MIN	MOMENTO LOBO MECÁNICO
UBICACIÓN EN EL ESPACIO			
MOVIMIENTO COREOGRÁFICO BDG			
MOVIMIENTO DEL VIDEO			
DESCRIPCIÓN DEL MOV. DEL VIDEO	• Respiración / Palpitación • Travellings lentos / Mov. hacia el interior.	• Movimiento circular aleatorio con cierta cadencia errática	
PIETAJE	• Tomas de ciudad / trajes • Close-ups respiraciones / cuerpos • Topografías en la ropa.	• Pietaje de escenas de lobos	
DIVISIÓN DE PANTALLAS	A 3648×144 960×144 B 1600×144 1984×144 C 2 A+D B+C	A+D = 4608×144 B+C = 3584×144 A D B C 2 A+D B+C	
DESCRIPCIÓN DE LA COREOGRAFÍA	- El movimiento es circular de arriba a abajo por la escalera eléctrica del subterráneo al 1er Piso. - Algunas integrantes de la BDG harán toques fragmentarios. ✳ Performance dará inicio con el cruce de la bandera	- El movimiento es radial alrededor del bandana del 1er Piso - Se va cerrando el círculo en dos direcciones, para concentrarse todos en la plataforma el elevador 1er Piso - Los integrantes miran hacia la pantalla y siguen a los lobos que tengan en su campo visual	- Grupo estático con movimiento interno mecánico - Toque de lobo más musical marcial. - Inicio de movimientos más en el grupo.
MOVIMIENTO DEL SONIDO	3° 2° 1° S	3° 1°	3°
DESCRIPCIÓN DEL SONIDO	- Centinelas / 3er Piso - Composición de fragmentos de órdenes (Free Jazz) ir con el pulso del video	- Centinelas / 3er Piso: interrumpidos sonoras con los "grupped frame" de los lobos (órdenes) eso se suma a: - BDG en primer Piso: aullido y ambientación orgánica	- Centinelas / 3er Piso: Toque militar (2 pantallas)

48

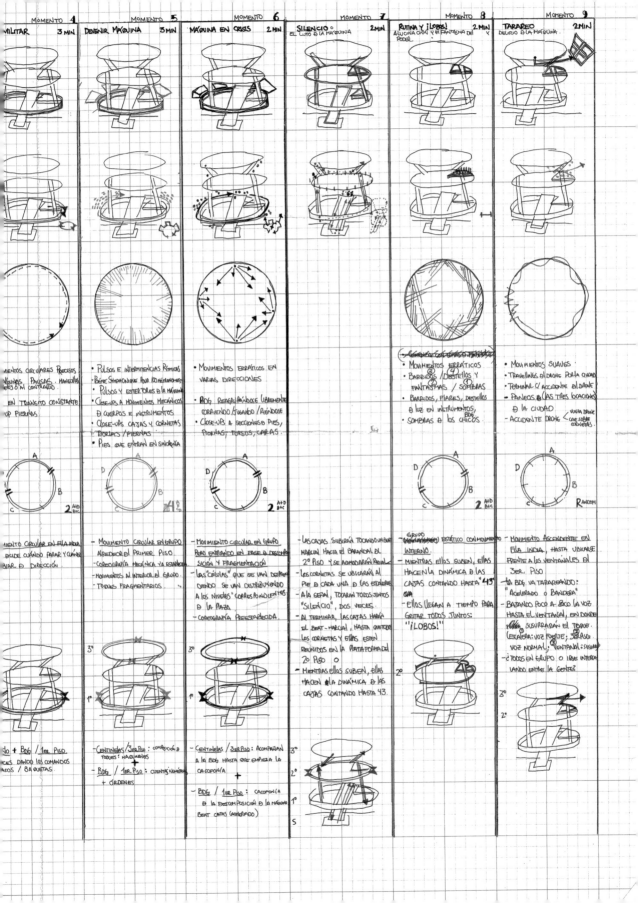

MOMENTO 4	MOMENTO 5	MOMENTO 6	MOMENTO 7	MOMENTO 8	MOMENTO 9
MILITAR 3 MIN	DEVENIR MÁQUINA 3 MIN	MÁQUINA EN CRISIS 2 MIN	SILENCIO 2 MIN / EL LUTO Ð LA MÁQUINA	RUTINA Y ¡LOBOS! 2 MIN / ALUCINACIÓN Y EL FANTASMA DEL PODER	TARAREO 2 MIN / DELIRIO Ð LA MÁQUINA

Texto descriptivo (fila central):

Momento 4:
...MIENTOS CIRCULARES PRECISOS
...QUINAS · PAUSAS · MARCHANDO
...OS Ó AL CONTRARIO
...EN TRÁNSITO CONSTANTE
...UP PIERNAS

Momento 5:
- PULSOS E INTERMITENCIAS RÍTMICAS
- Pièce Symphonique pour 100 hérissons ?
- PULSOS Y ESTERTORES Ð LA MÁQUINA
- CLOSE-UPS A MOVIMIENTOS MECÁNICOS Ð CUERPOS E INSTRUMENTOS
- CLOSE-UPS CAJAS Y CORNETAS BIORUAS / PIERNAS
- PIES QUE ENTRAN EN SINCRONÍA

Momento 6:
- MOVIMIENTOS ERRÁTICOS EN VARIAS DIRECCIONES
- BDG REAGRUPÁNDOSE LIBREMENTE CORRIENDO / JUGANDO / RIÉNDOSE
- CLOSE-UPS A SECCIONES Ð PIES, PIERNAS, TORSOS, CARAS.

Momento 8:
- COMIENZA CON GRUPO FANTASMA
- MOVIMIENTOS ERRÁTICOS
- BARRIDOS / DESTELLOS Y FANTASMAS / SOMBRAS
- BARRIDOS, PILARES, DESTELLOS Ð LUZ EN INSTRUMENTOS, BDG
- SOMBRAS Ð LOS CHICOS

Momento 9:
- MOVIMIENTOS SUAVES
- TRAVELLINGS ÐL DRONE POR LA CIUDAD
- TERMINAL C/ ACCIDENTE ÐL DRONE
- PANEOS Ð LAS TRES LOCACIONES Ð LA CIUDAD
- ACCIDENTE DRONE < VUELA DRONE / CAE SOBRE CORNETAS

Texto descriptivo (fila inferior):

Momento 4:
...MIENTO CIRCULAR EN FILA INDIA
...ECIDE CUÁNDO PARAR Y CUÁNDO
...IAR Ð DIRECCIÓN

Momento 5:
- MOVIMIENTO CIRCULAR EN GRUPO ALREDEDOR ÐL PRIMER PISO
- COREOGRAFÍA MECÁNICA YA ESTABLECIDA
- MOVIMIENTOS AL INTERIOR ÐL GRUPO
- TOQUES FRAGMENTARIOS

Momento 6:
- MOVIMIENTO CIRCULAR EN GRUPO PERO ENTRANDO EN FASE Ð DESCOMPOSICIÓN Y FRAGMENTACIÓN
- LAS "CÉLULAS" QUE SE VAN DIVIDIENDO SE VAN DISTRIBUYENDO A LOS NIVELES CORRESPONDIENTES Ð LA PLAZA
- COREOGRAFÍA PREESTABLECIDA

Momento 7:
- LAS CAJAS SUBIRÁN TOCANDO UN BEAT MARCIAL HACIA EL BARANDAL ÐL 2° PISO Y SE ACOMODARÁN RADIAL
- LOS CORNETAS SE UBICARÁN AL PIE Ð CADA UNA Ð LAS ESCALERAS
- A LA SEÑAL, TOCARÁN TODOS JUNTOS "SILENCIO", DOS VECES.
- AL TERMINAR, LAS CAJAS HARÁN EL BEAT - MARCIAL, HASTA QUE TODOS LOS CORNETAS Y ELLAS ESTÉN REUNIDOS EN LA PLATAFORMA ÐL 2° PISO
- MIENTRAS ELLOS SUBEN, ELLAS HACEN Ð LA DINÁMICA Ð LAS CAJAS CONTANDO HASTA 43.

Momento 8:
- GRUPO (FANTASMA) ESTÁTICO CON MOVIMIENTO INTERNO.
- MIENTRAS ELLOS SUBEN, ELLAS HACEN LA DINÁMICA Ð LAS CAJAS CONTANDO HASTA "43" C/U
- ELLOS LLEGAN A TIEMPO PARA GRITAR TODOS JUNTOS: "¡LOBOS!"

Momento 9:
- MOVIMIENTO ASCENDENTE EN FILA INDIA, HASTA UBICARSE FRENTE A LOS VENTANALES ÐL 3er. PISO
- LA BDG VA TARAREANDO: "ACELERADO O BANDERA"
- BAJANDO POCO A POCO LA VOZ HASTA EL VENTANAL, EN DONDE SUSURRARÁN EL TOQUE. (ESCALERA: VOZ FUERTE; SE BAJA VOZ NORMAL; VENTANAL: SUSURRO)
- ¿TODOS EN GRUPO O IRSE INTERCALANDO ENTRE LA GENTE?

Texto (fila final):

Momento 4:
...JO + BDG / 1er PISO
...ACES DANDO LOS COMANDOS
...ASOS / BAQUETAS

Momento 5:
- CENTINELAS / 3er PISO: COMPOSICIÓN Ð TOQUES + MÁQUINAS
- BDG / 1er PISO: CUENTAS NUMÉRICAS + ÓRDENES

Momento 6:
- CENTINELAS / 3er PISO: ACOMPAÑAN A LA BDG HASTA QUE EMPIEZA LA CACOFONÍA
- BDG / 1er PISO: CACOFONÍA Ð LA DESCOMPOSICIÓN Ð LA MÁQUINA BEAT CAJAS (ACELERADO)

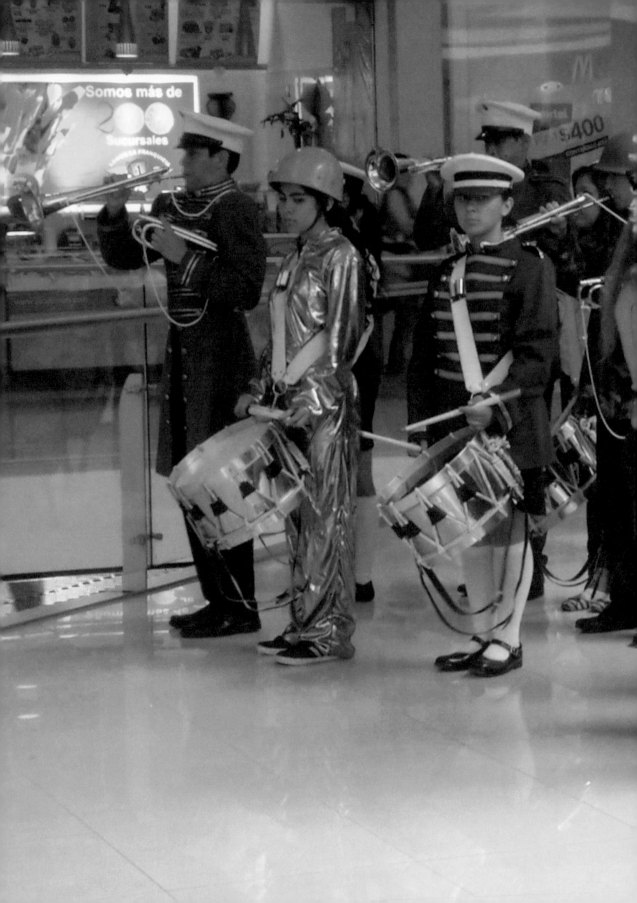

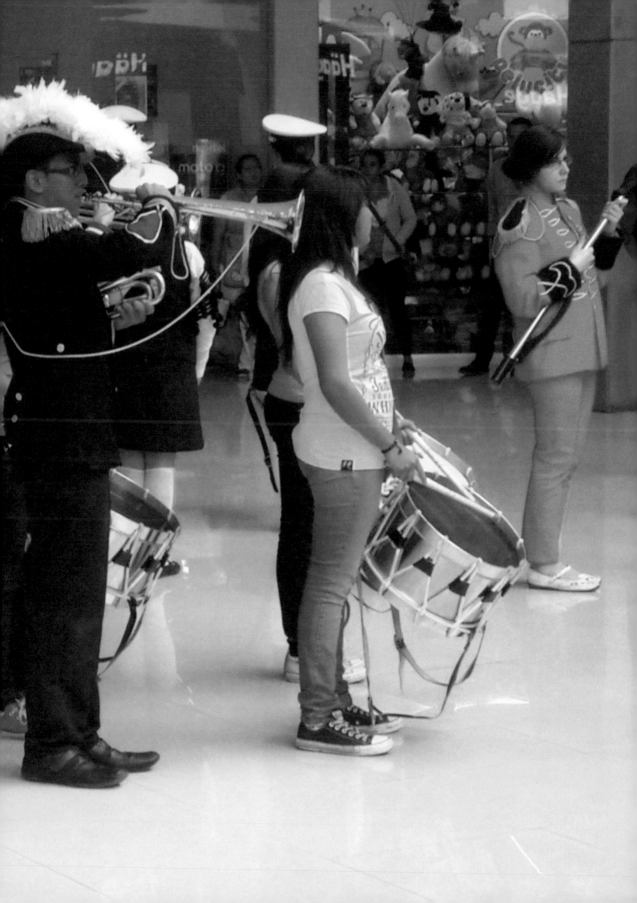

ICHIBAN
sushi house

Adulto $125
Niños $65

BIENVENIDAS TARJETAS VISA

EL SEMILLERO

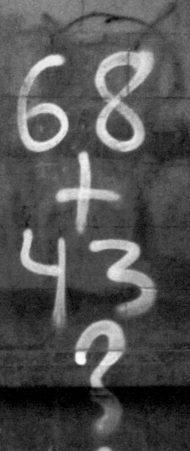

Graffiti in downtown Mexico City

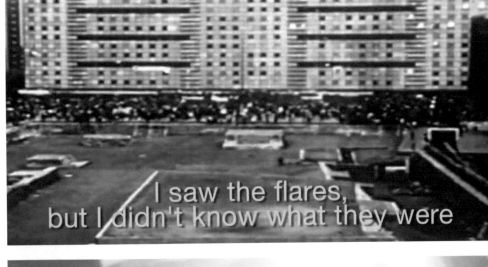

I saw the flares,
but I didn't know what they were

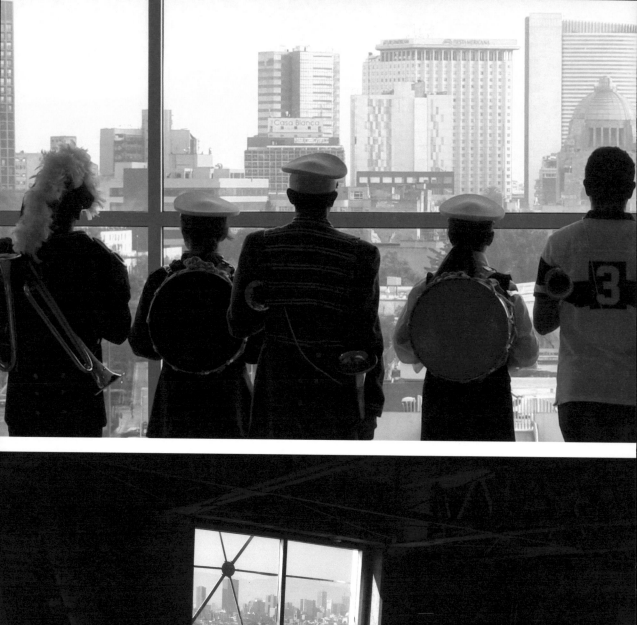
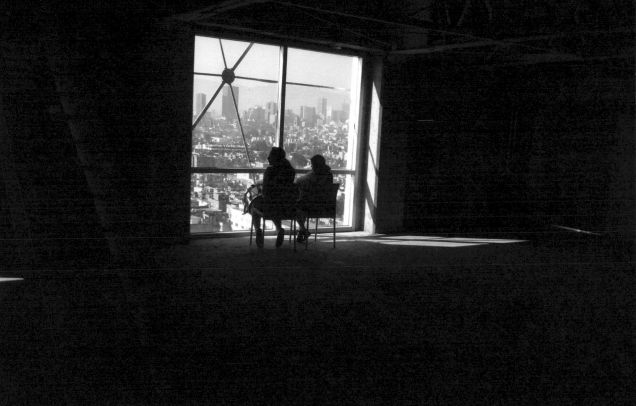

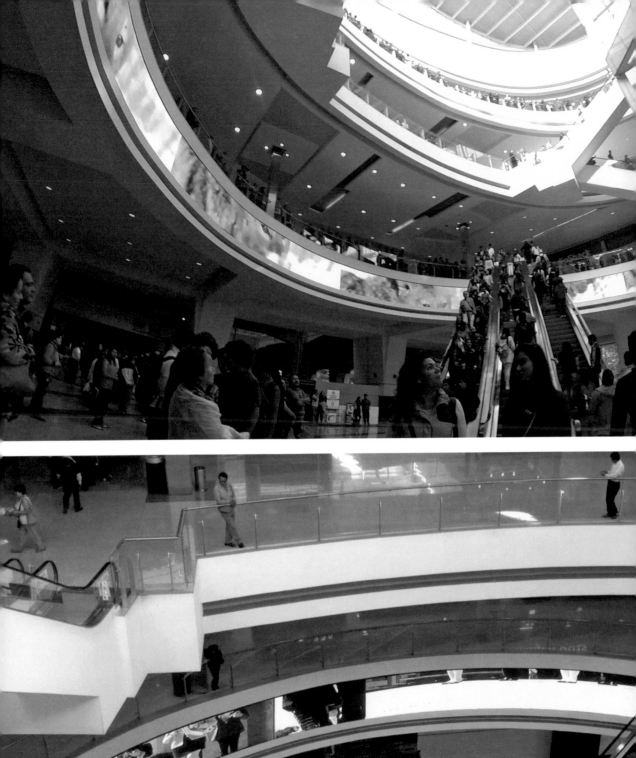
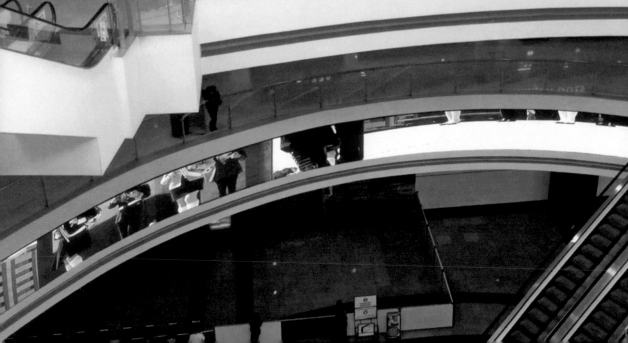

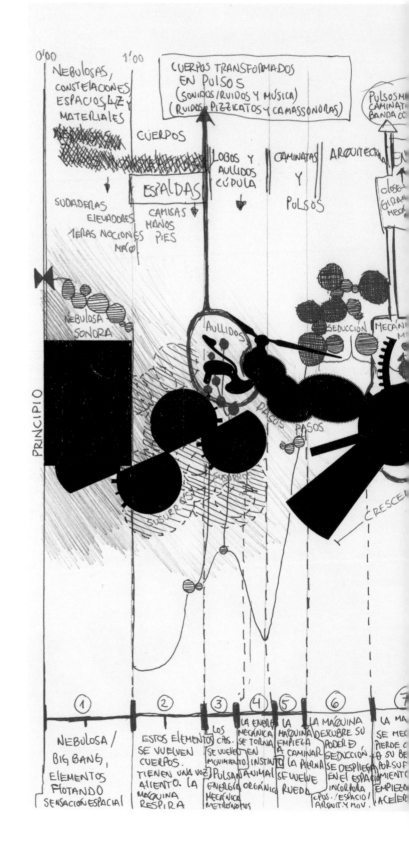

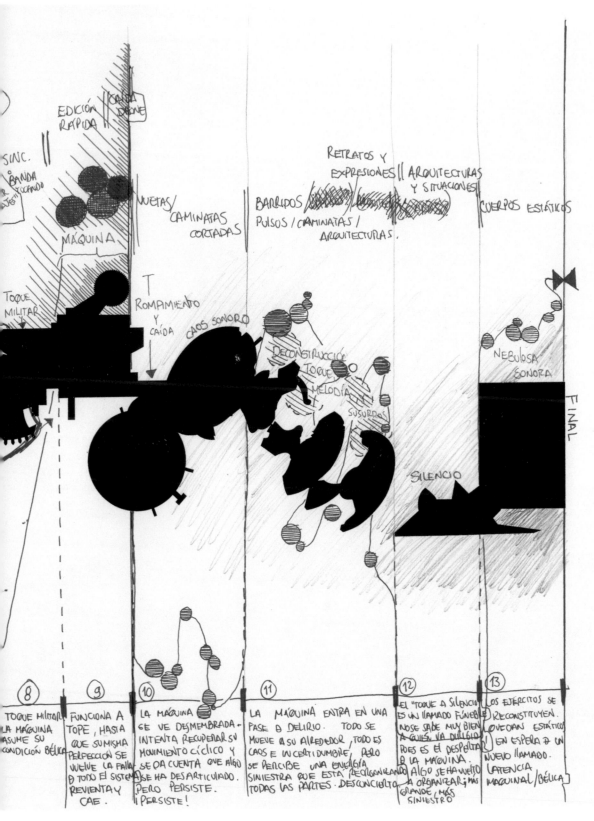

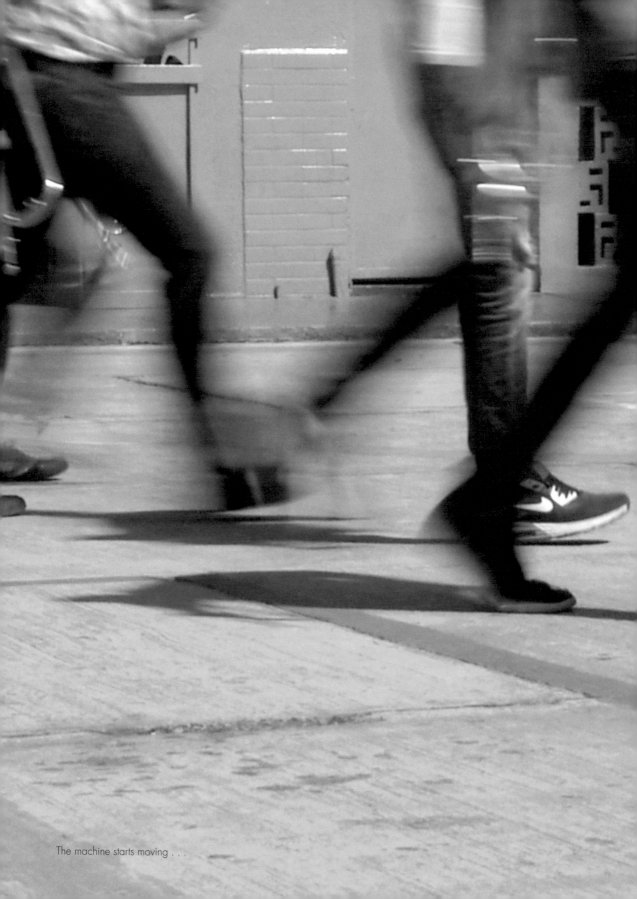

The machine starts moving . . .

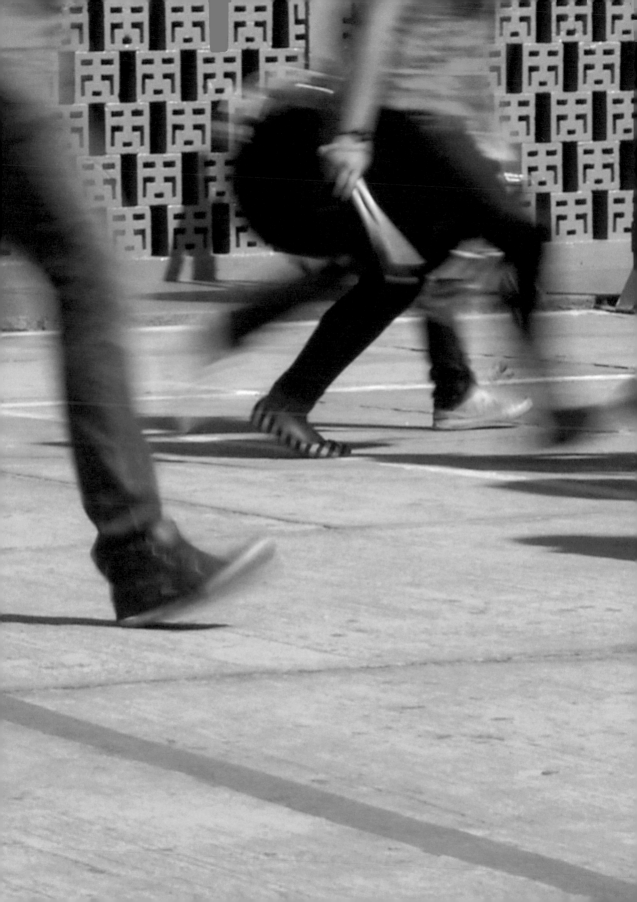

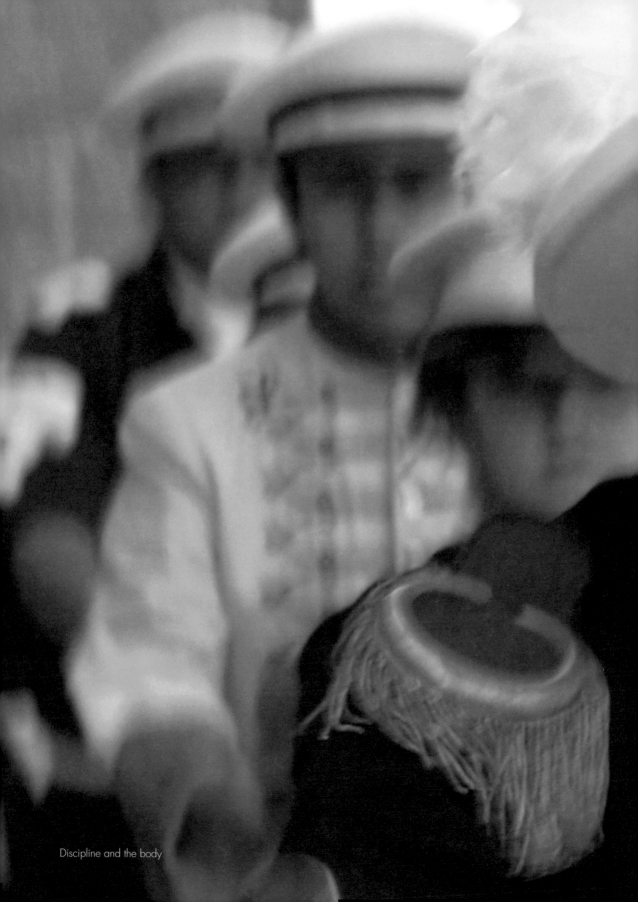

Discipline and the body

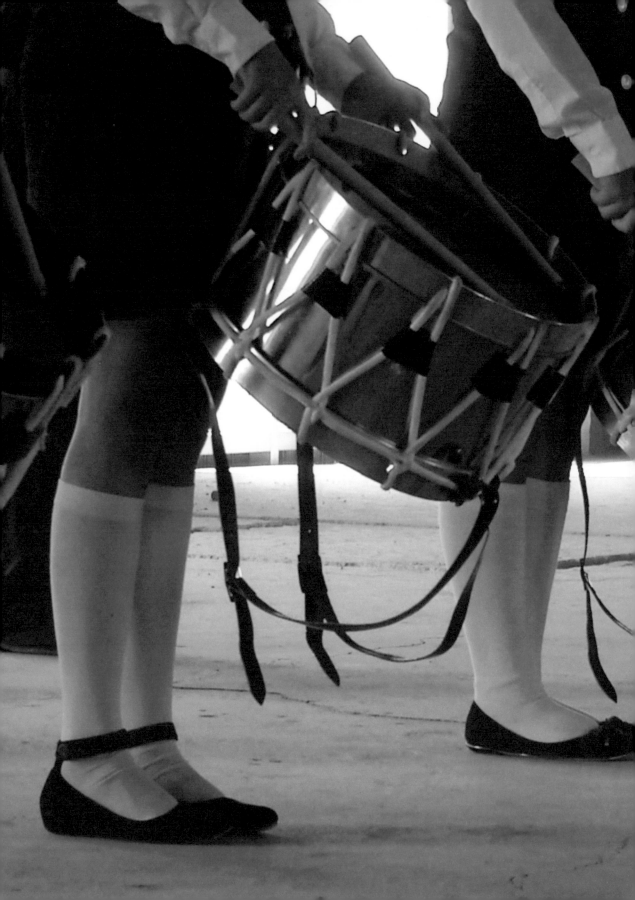

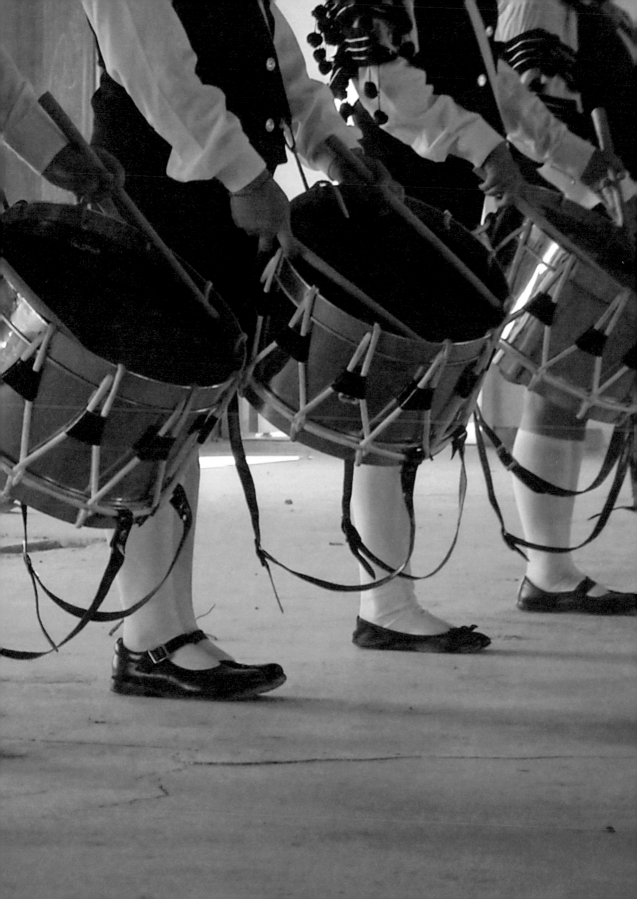

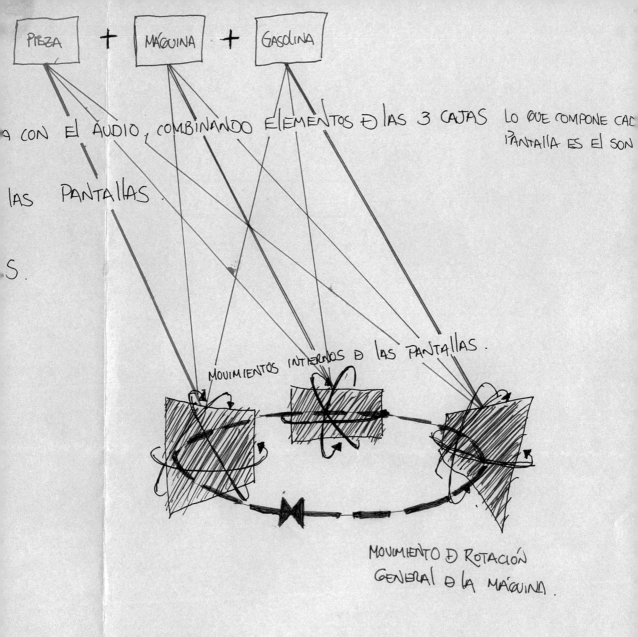

PIEZA + MÁQUINA + GASOLINA

A CON EL AUDIO, COMBINANDO ELEMENTOS D LAS 3 CAJAS LO QUE COMPONE CAC PANTALLA ES EL SON

LAS PANTALLAS.

S.

MOVIMIENTOS INTERNOS D LAS PANTALLAS.

MOVIMIENTO D ROTACIÓN GENERAL D LA MÁQUINA.

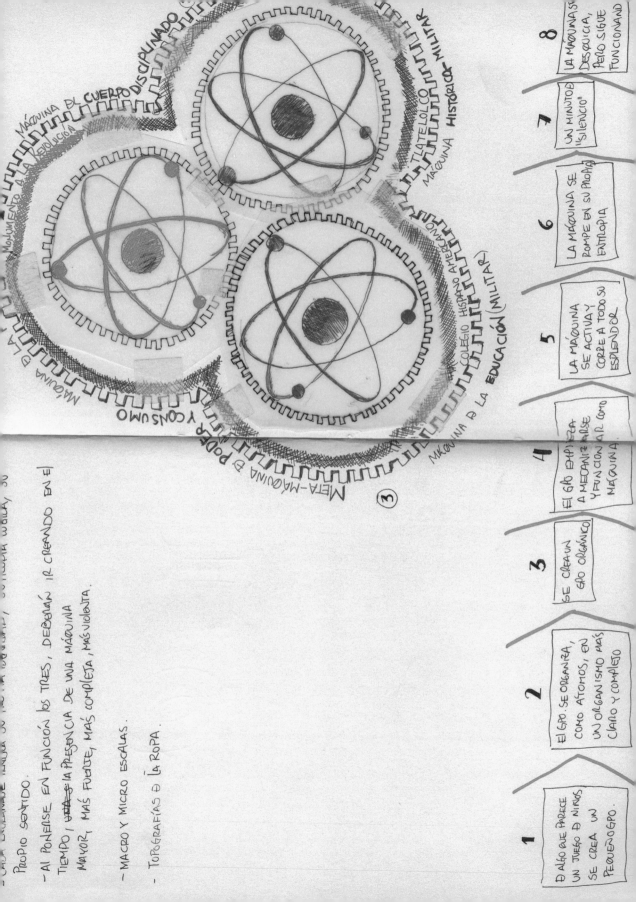

MÁQUINA DEL CUERPO DISCIPLINADO

MÁQUINA DEL MONUMENTO A LA REVOLUCIÓN

MÁQUINA DE LA ...

MÁQUINA DE PODER Y CONSUMO

③ META-MÁQUINA DE PODER Y CONSUMO

TLATELOLCO / MÁQUINA HISTÓRICO-MILITAR

COLEGIO HISPANO AMERICANO / MÁQUINA DE LA EDUCACIÓN (MILITAR)

... CREA ... TALLA SU ... / SOTOPÍA WOLLA, SU

PROPIO SENTIDO.

- AL PONERSE EN FUNCIÓN LOS TRES, DEBERÍAN IR CREANDO EN EL TIEMPO, ~~una~~ LA PRESENCIA DE UNA MÁQUINA MAYOR, MÁS FUERTE, MÁS COMPLETA, MÁS VIOLENTA.

- MACRO Y MICRO ESCALAS.

- TOPOGRAFÍAS DE LA ROPA.

1 D ALGO QUE PARECE UN JUEGO DE NIÑOS, SE CREA UN PEQUEÑO GPO.

2 EL GPO. SE ORGANIZA, COMO ÁTOMOS, EN UN ORGANISMO MÁS CLARO Y COMPLEJO

3 SE CREA UN GPO ORGÁNICO

4 EL GPO EMPIEZA A MECANIZARSE Y FUNCIONAR COMO MÁQUINA

5 LA MÁQUINA SE ACTIVA Y CORRE A TODO SU ESPLENDOR

6 LA MÁQUINA SE ROMPE EN SU PROPIA ENTROPÍA

7 UN MINUTO DE "SILENCIO"

8 LA MÁQUINAS DESQUICIA, PERO SIGUE FUNCIONANDO

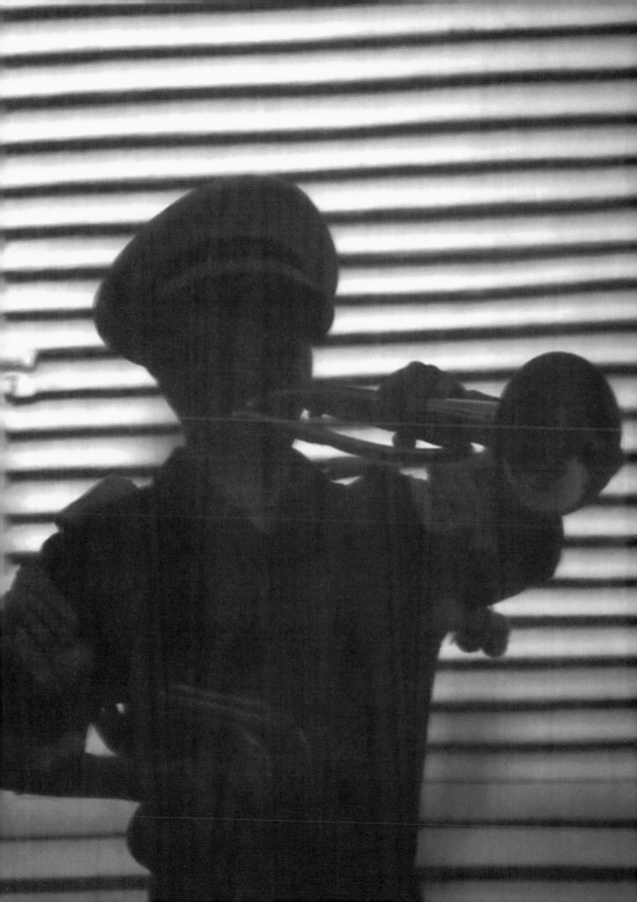

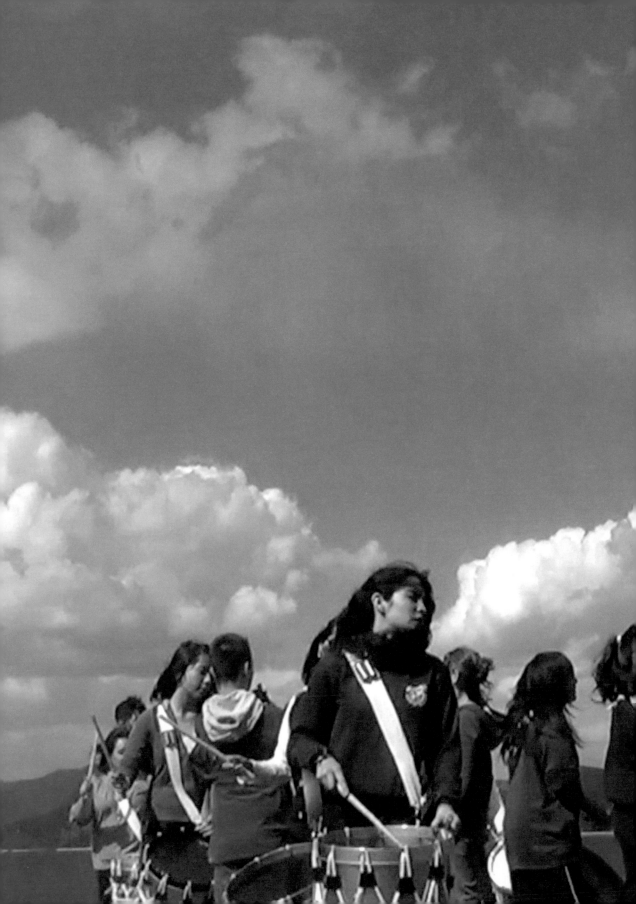

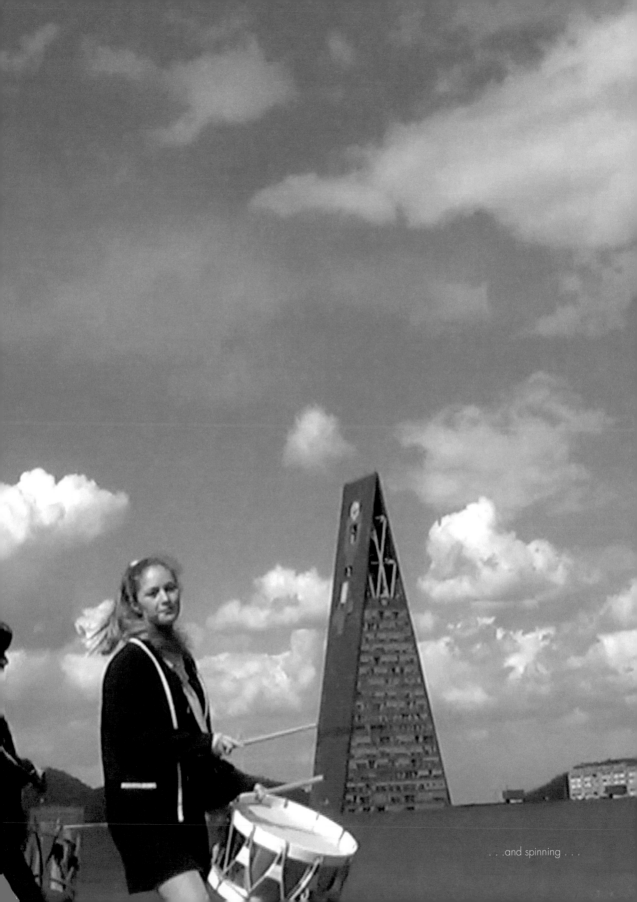

. . .and spinning . . .

Silence: exhaustion and fatigue of the machine

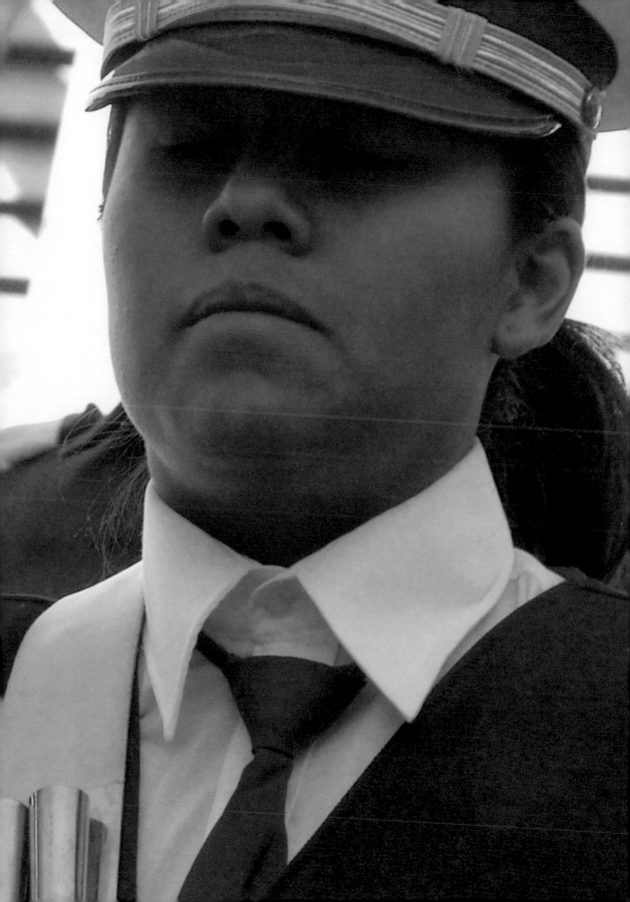

Collapse: the machine is the State

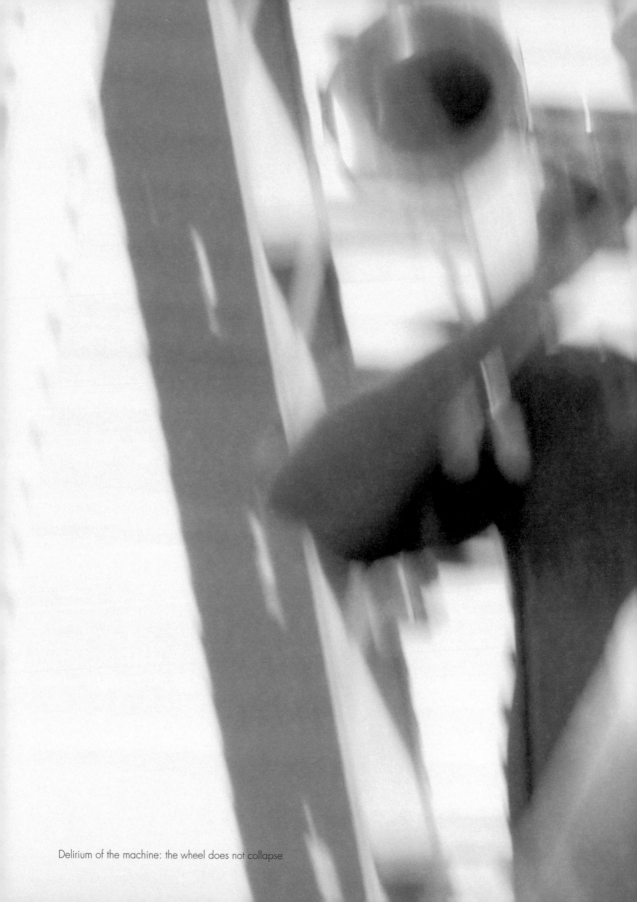

Delirium of the machine: the wheel does not collapse

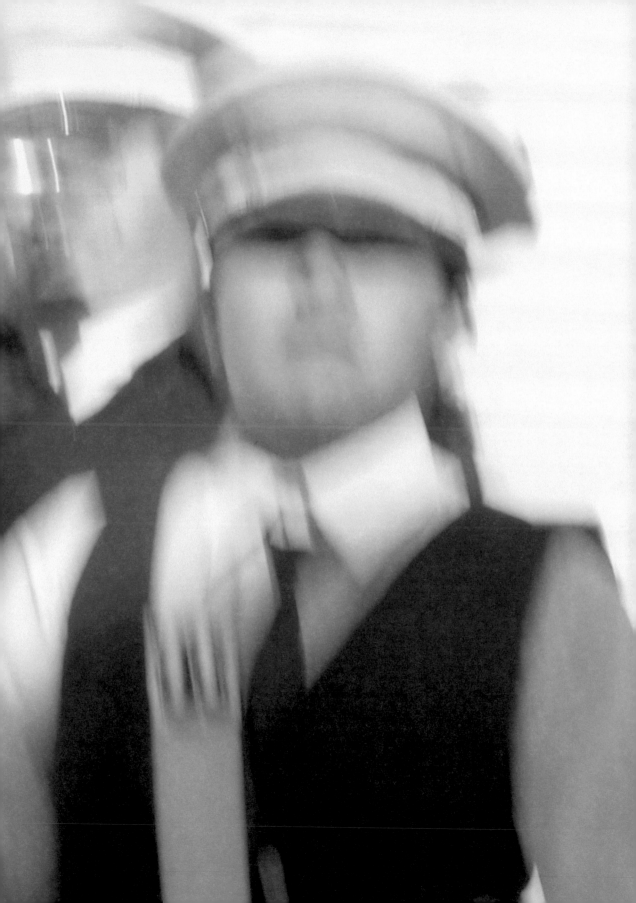

The machine reassembles

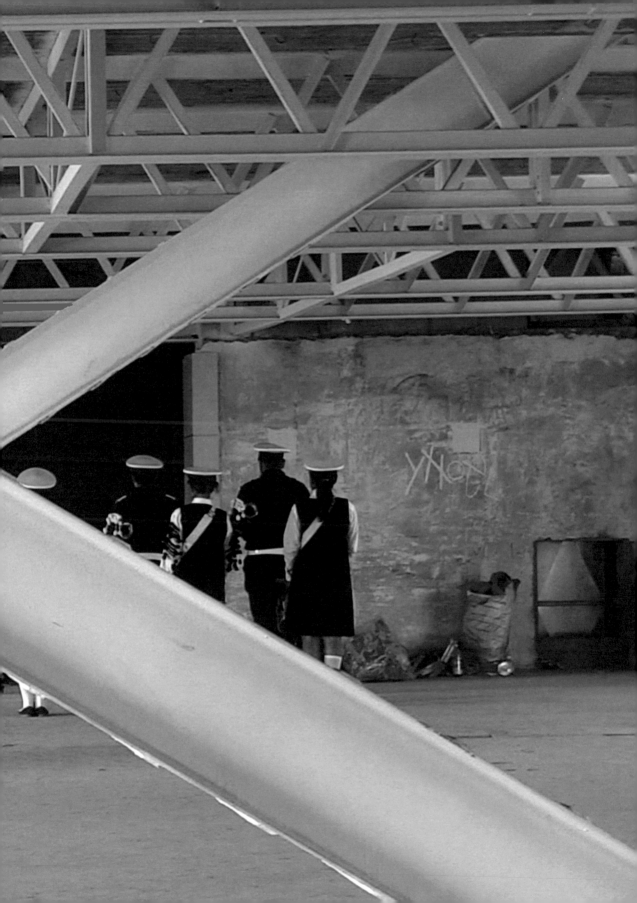

pulsos - con arco
(ref 11.12)

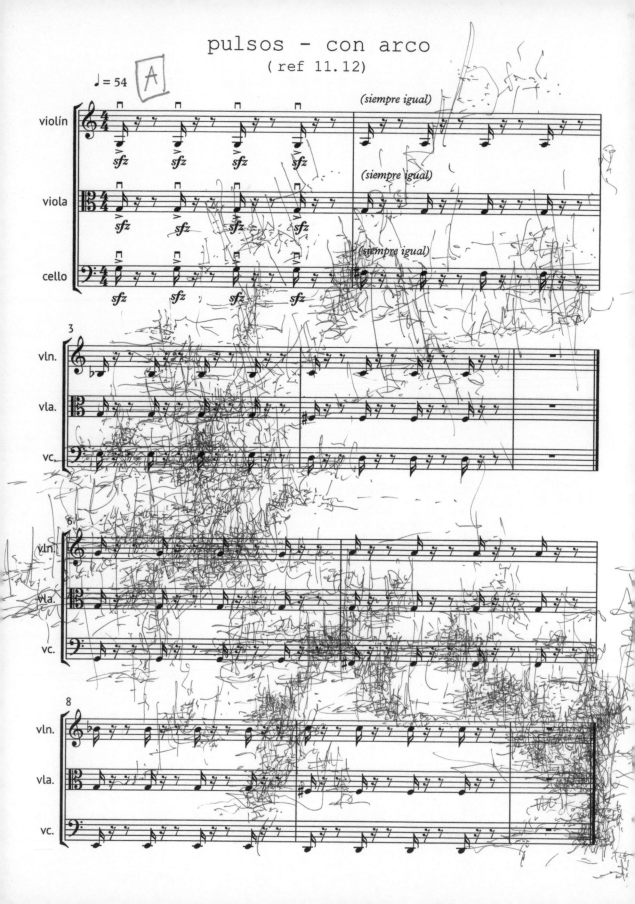

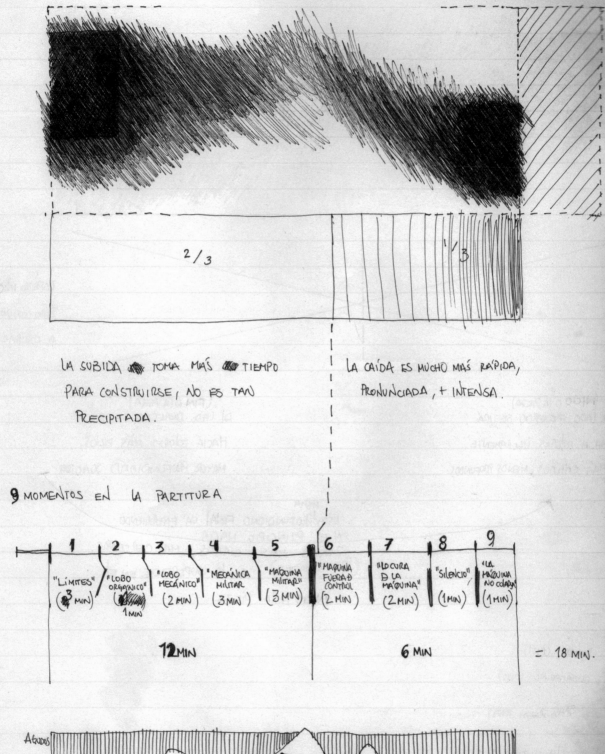

2/3 1/3

LA SUBIDA ▓ TOMA MÁS ▓ TIEMPO
PARA CONSTRUIRSE, NO ES TAN
PRECIPITADA.

LA CAÍDA ES MUCHO MÁS RÁPIDA,
PRONUNCIADA, + INTENSA.

9 MOMENTOS EN LA PARTITURA

| 1 | 2 | 3 | 4 | 5 | 6 | 7 | 8 | 9 |

"LÍMITES"
(3 MIN)

"LOBO
ORGÁNICO"
(1 MIN)

"LOBO
MECÁNICO"
(2 MIN)

"MECÁNICA
MILITAR"
(3 MIN)

"MÁQUINA
MILITAR"
(3 MIN)

"MÁQUINA
FUERA D
CONTROL"
(2 MIN)

"LOCURA
D LA
MÁQUINA"
(2 MIN)

"SILENCIO"
(1 MIN)

"LA
MÁQUINA
NO COLAPSA"
(1 MIN)

12 MIN 6 MIN = 18 MIN.

AGUDOS

Ⓐ

Ⓑ

GRAVES

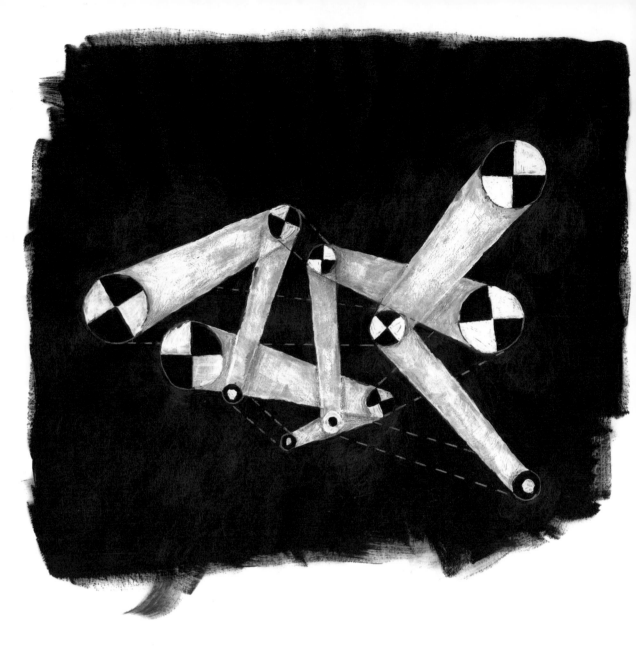

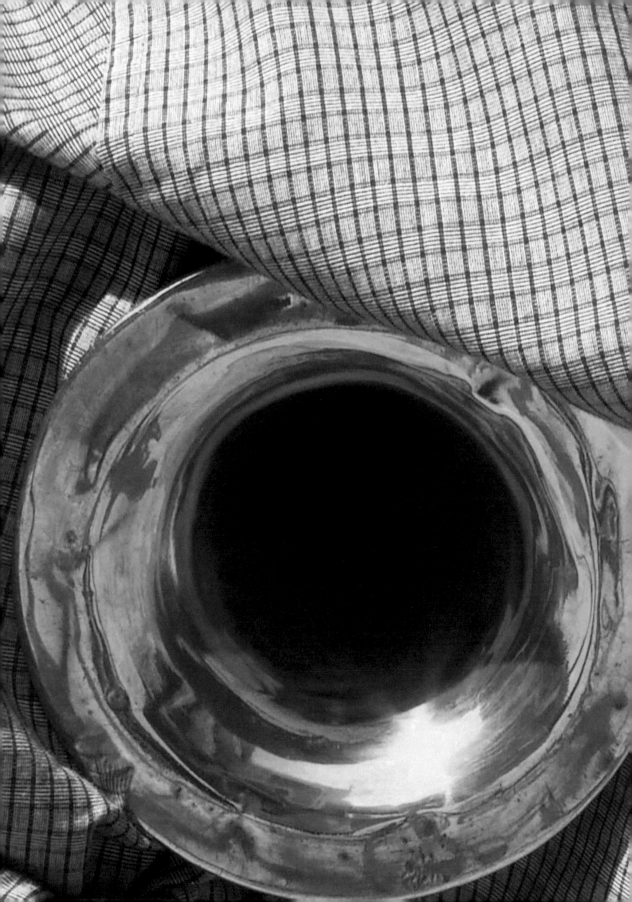

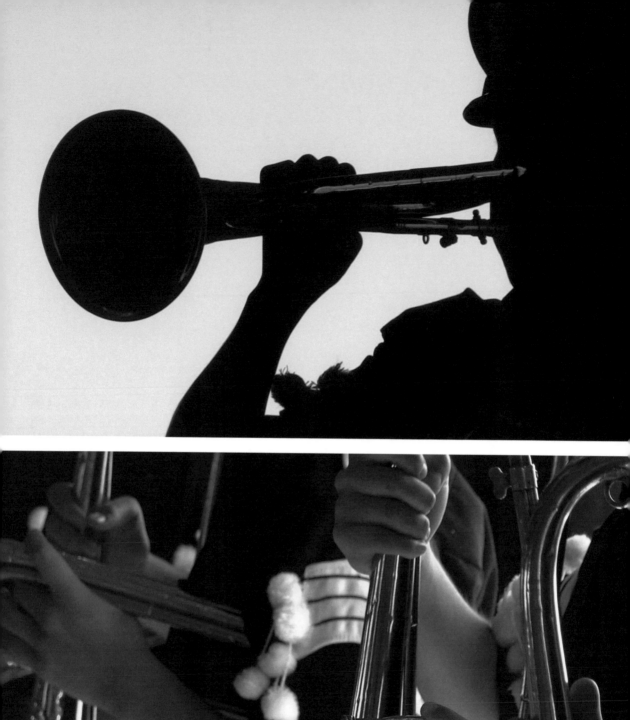

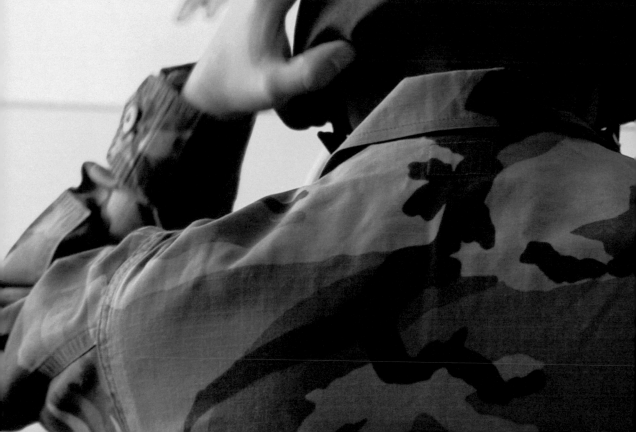

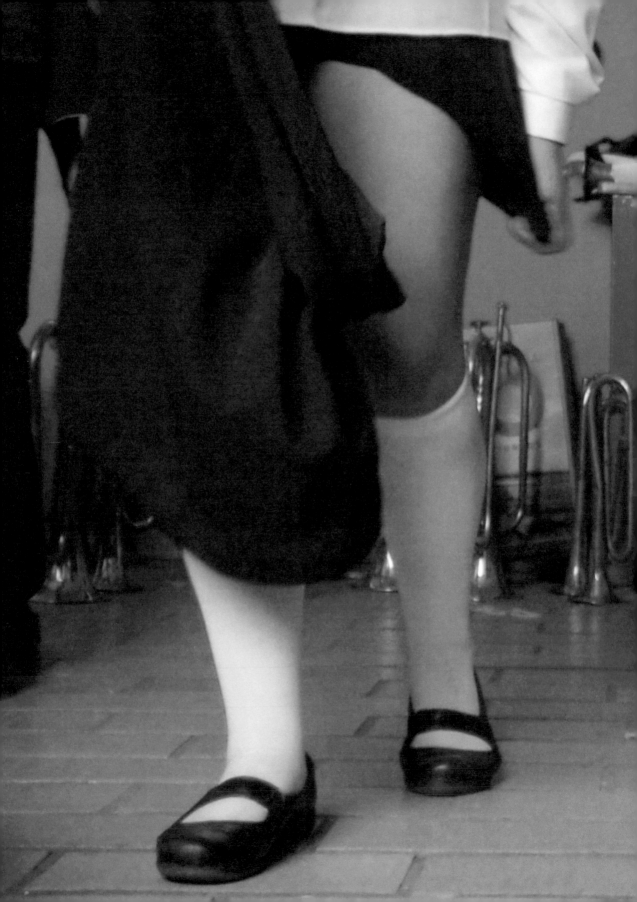

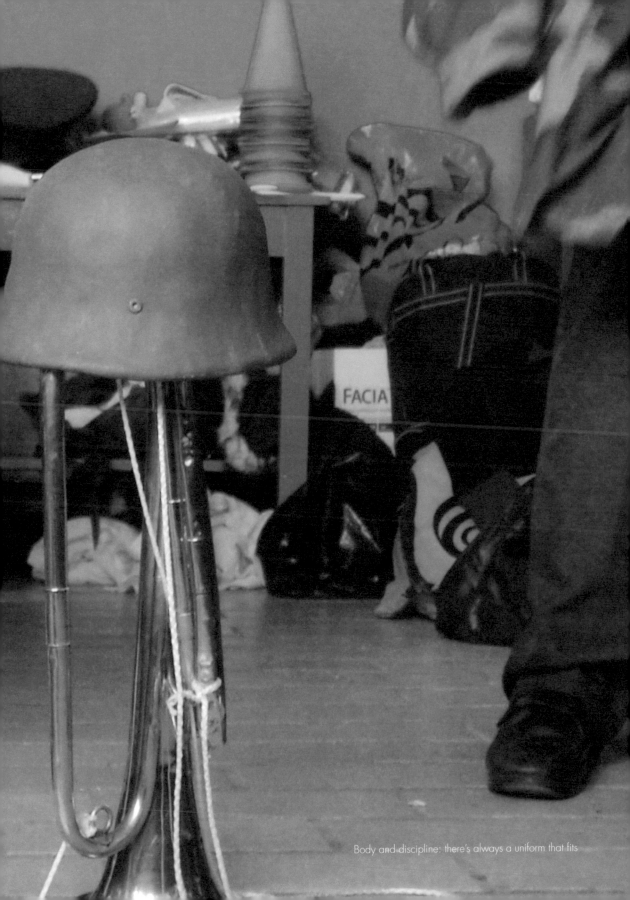

Body and discipline: there's always a uniform that fits

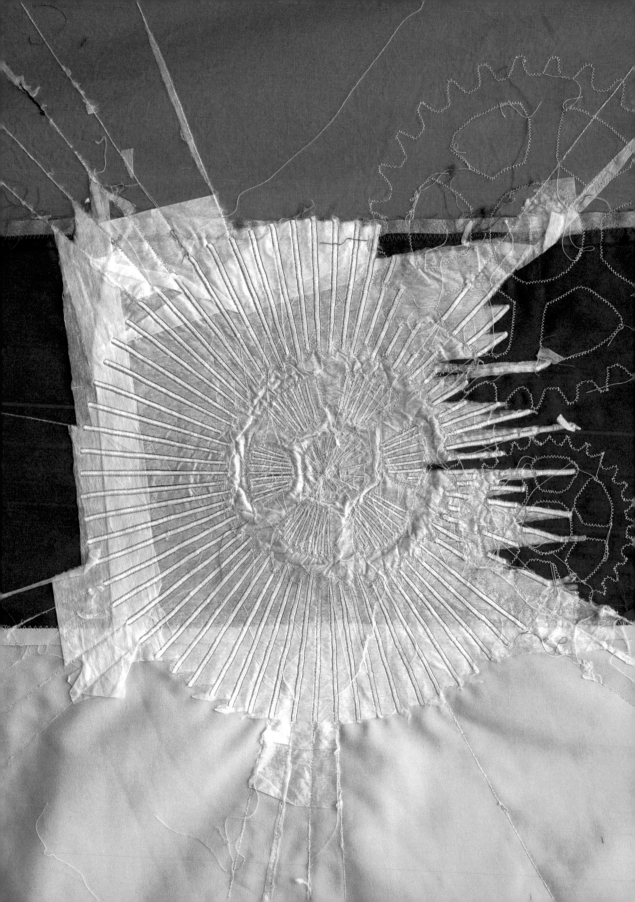

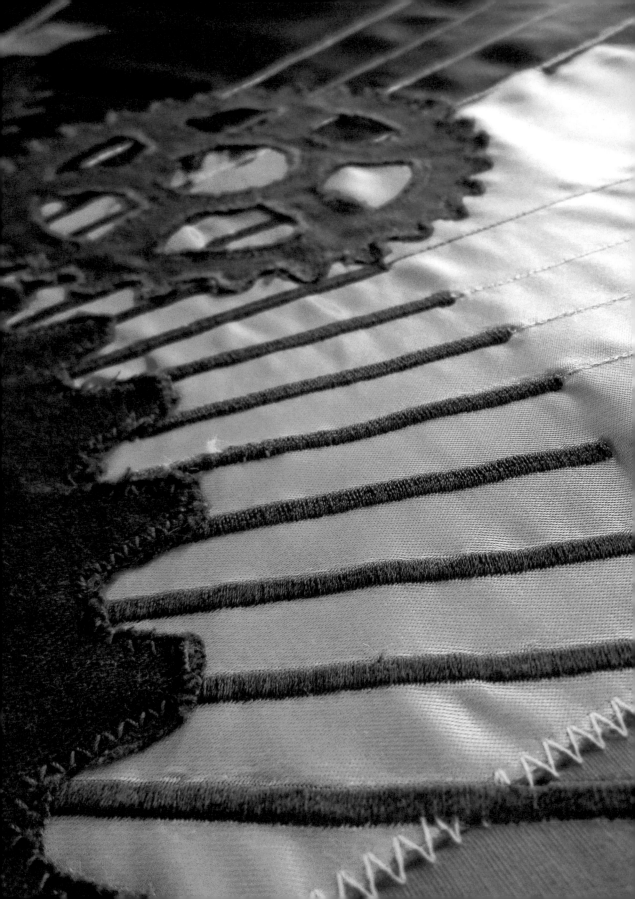

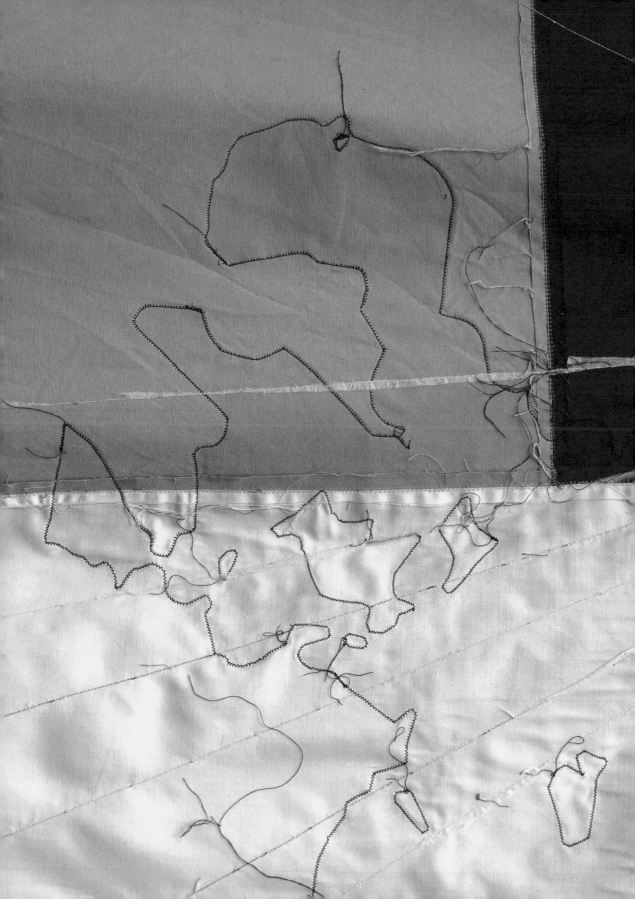

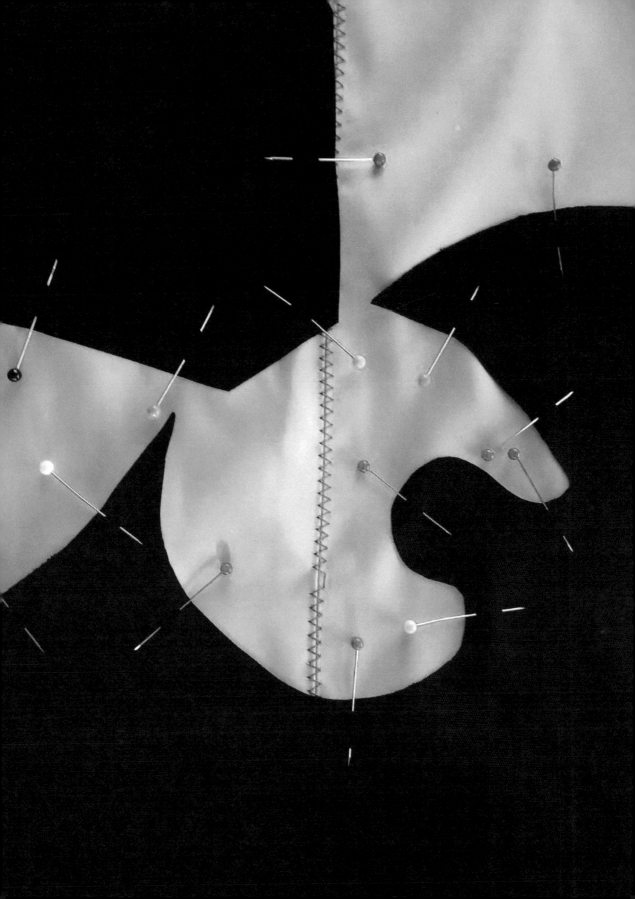

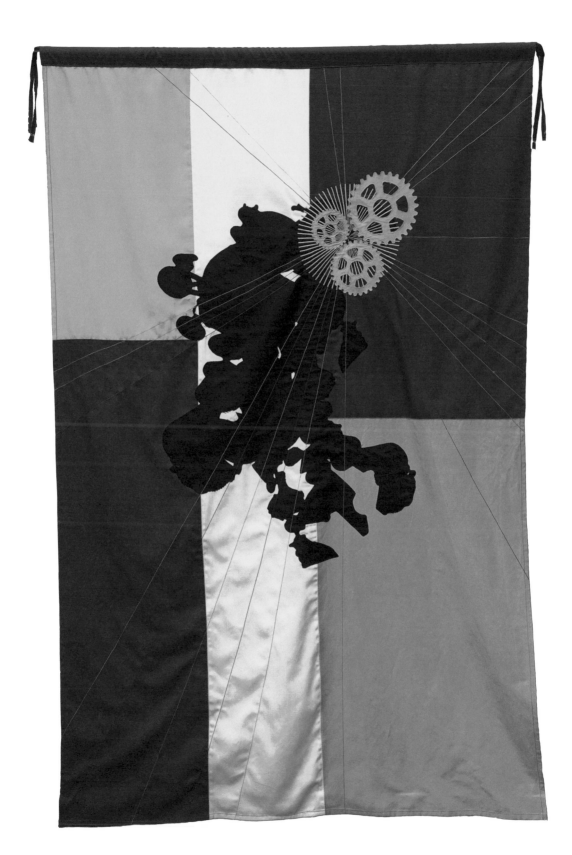

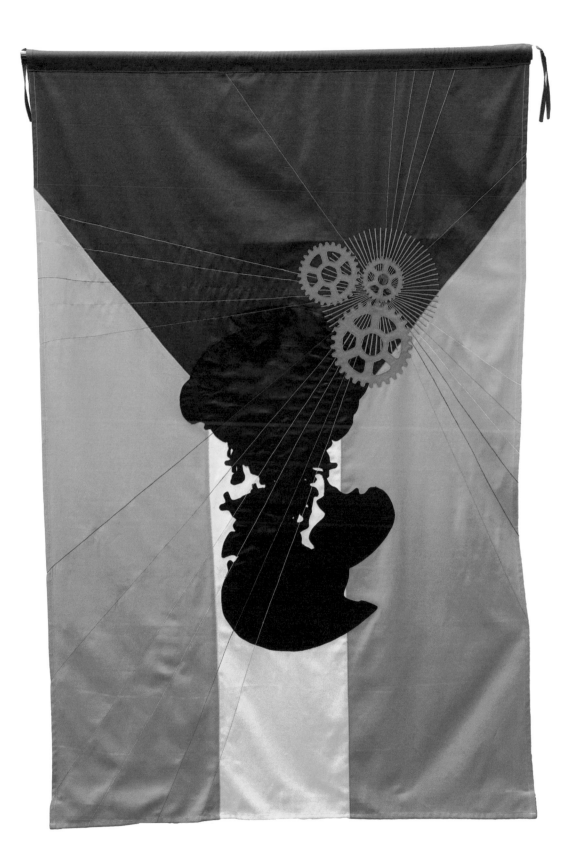

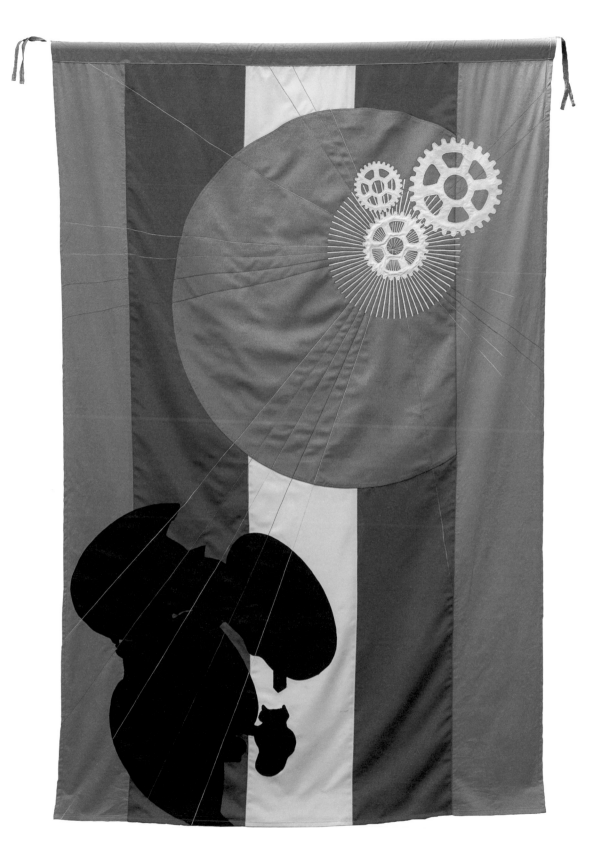

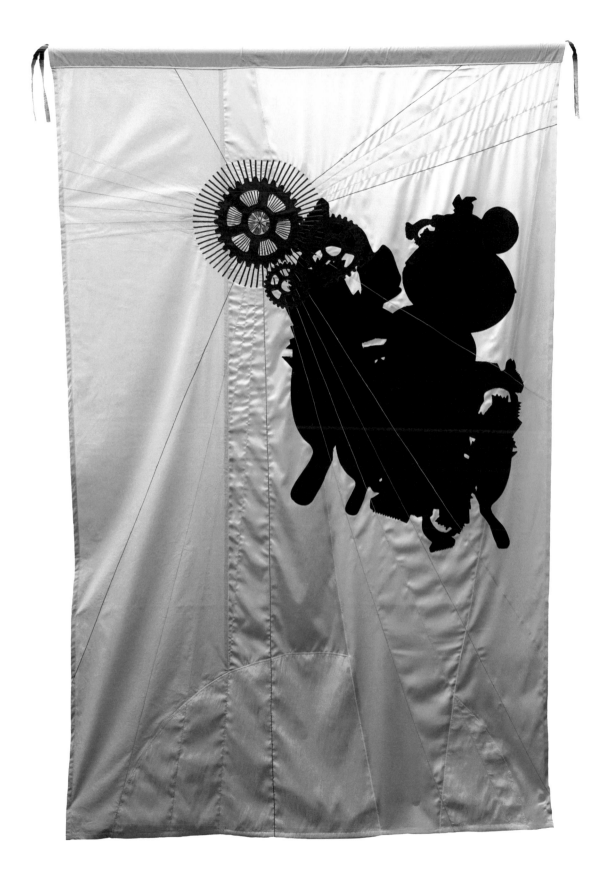

INDEX

As captured in the preceding section of images, the following descriptions by Erick Meyenberg relate to the process, performances, and realization of *The wheel bears no resemblance to a leg*. Each number references the page on which the image appears, as well as its corresponding component part in the machine diagram.

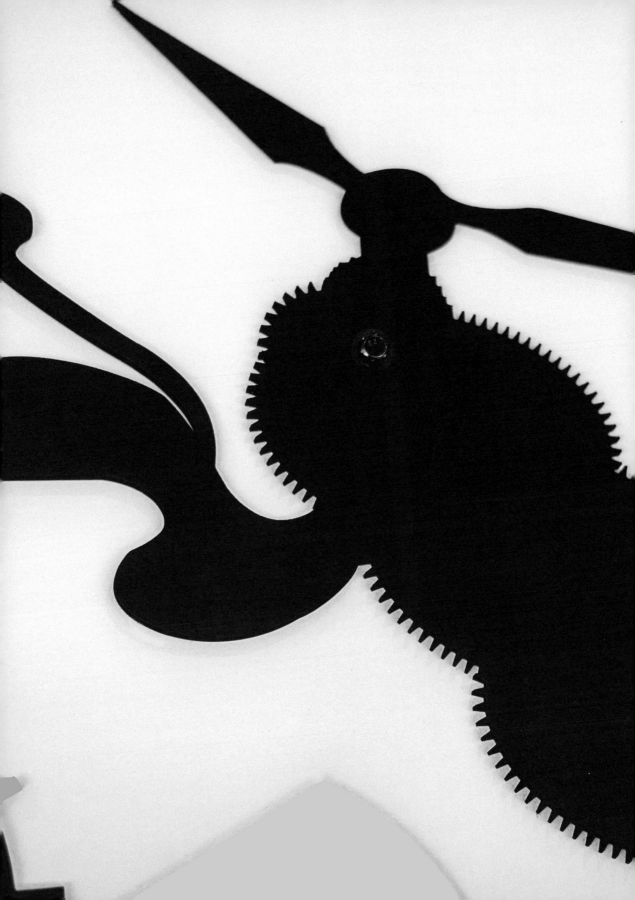

COMPONENTS OF *THE WHEEL BEARS NO RESEMBLANCE TO A LEG*

*Unless otherwise indicated, all components were presented at both Yerba Buena Center for the Arts, San Francisco and Americas Society, New York

Banderas I–IV (Territorio, Tropa & Orden) [Flags IV (Territory, Troops & Order)], 2016
Embroidered fabric, wooden pole, metal stand
Variable dimensions
Courtesy of the artist

Cavamos una fosa [We dig a grave], 2016
Cut vinyl, trumpet, helmet
Variable dimensions
Courtesy of the artist and Antonio Pérez Tapia, Director of Banda de Guerra Lobos
Exhibited at Yerba Buena Center for the Arts, San Francisco

Helmet & TRUMPet: *Power and Control*, 2017
Painted metal & fiber glass
Courtesy of the artist and Antonio Pérez Tapia, Director of Banda de Guerra Lobos
Exhibited at Americas Society, New York

La Grande Machine [The Big Machine], 2015
Galvanized metal, neoprene, anodized screws
305 x 105.5 cm (120 1/16 x 41 9/16 in.)
Courtesy of The Buenaventura Collection, Tijuana

La rueda no se parece a una pierna [The wheel bears no resemblance to a leg], 2016
Three-channel color video and audio installation
16:08 min.
Courtesy of the artist

Production coordinator: Sergio Olivares
Photography: Julien Devaux, Katri Walker and Erick Meyenberg
Editing: Martha Uc and Erick Meyenberg
Live recording: Félix Blume and Raúl Locatelli
Musical composition: Alejandro Castaños
Sound design: Félix Blume and Erick Meyenberg
Choreography: Nadia Lartigue and Esthel Vogrig
Color correction: Jorge Romo
Wardrobe: Adriana Olivera
Production assistance: Mariano Arribas

Co-participants: Antonio Pérez Tapia (Director of Banda de Guerra Lobos), Ernesto Berumen Herrera, Abigail Díaz Gómez, Cassandra Itzel Gaona Hernández, Jaqueline Michelle Gutiérrez García, Julio César Hernández, Amanda Martínez Bordona, Leslie Mejía Ramos, Mauricio Morales Nolasco, Moises Morales Nolasco, Mariana Mudrow Bernal Ramírez, Axel Ortiz Moreno, Carolina Ortiz Ramírez, Karla Pech Sotelo, Natali Rodríguez, José Antonio Rodríguez Delgado, Giego Rodríguez Hernández, Luz Montserrat Rodríguez Ornelas, Alan Job Rubio González, Elisa Pilar Salazar Gaitan, Brenda Strempler Alcibar, Jassina Torres Kassab, Sebastián Varguez López, Gerardo Gabriel Victorino Gómez, Samanta Zagal Aquino, Arantza Zamora Esquivel (members of the Banda de Guerra Lobos of the Colegio Hispanoamericano).

Research and process materials, 2014–16
Drawings and diagrams, notes, Internet-based photographic images, paper cut-outs, collages, fabric samples, video stills, HD video (color, 6:01 min.)
Variable dimensions
Courtesy of the artist

TABLE OF CONTENTS

Foreword

The wheel bears no resemblance to a leg is the first major presentation of Erick Meyenberg's work in the United States. Combining preparatory works from the research process, hand-sewn flags, and a multi-channel projection, the project is the result of Meyenberg's extended engagement with the Banda de Guerra Lobos, the high school marching band at Colegio Hispanoamericano in Mexico City. Meyenberg's complex installation produces a synesthetic experience that serves to raise important critical questions about contemporary Mexican realities, and both Americas Society and Yerba Buena Center for the Arts are pleased to bring much deserved attention to the artist and his significant project.

The wheel bears no resemblance to a leg was originally commissioned by inSite/Casa Gallina, 2014–16. The project was made possible through the generous support of Cámara de Diputados (México), Secretaría de Cultura (México), and Fundación Jumex Arte Contemporáneo, as well as the curators Osvaldo Sánchez (Artistic Director, Casa Gallina) and Josefa Ortega (Curator, Casa Gallina), whose continuing support has been invaluable. We would also like to thank inSite Executive Director Michael Krichman and Casa Gallina Executive Director Carmen Cuenca for their support of Meyenberg and this work from the very beginning.

As collaboration represents an integral facet of Meyenberg's process, collaboration among our respective institutions and inSite/Casa Gallina has been essential to the realization of the exhibition and this accompanying publication. Gabriela Rangel (Director, Visual Arts and Chief Curator, Americas Society), Lucía Sanromán (Director of Visual Arts, Yerba Buena Center for the Arts), and Osvaldo Sánchez and Josefa Ortega have played critical organizational and curatorial roles in the success of the project.

We have received the support of numerous lenders, donors, and institutions who have generously contributed to the project. We thank the Buenaventura Collection, Tijuana for lending *La Grande Machine*. At YBCA, we are grateful for the support of the Panta Rhea Foundation, especially Executive Director Diana Cohn and board member Hans Schoepflin; the Consulate General of Mexico in San Francisco; and the Mexican Agency for International Development Cooperation. Additional support at YBCA was provided by Mike Wilkins and Sheila Duignan, Meridee Moore and Kevin King, and the Creative Ventures Council. Program support at YBCA was provided by the James Irvine Foundation, the National Endowment for the Arts, Adobe, Abundance Foundation, Gaia Fund, Grosvenor, and members of Yerba Buena Center for the Arts. YBCA wishes to thank Directors Forum Members for underwriting Free First Tuesdays and the City of San Francisco for its ongoing support. Americas Society also wishes to acknowledge the generous support of the Panta Rhea Foundation, as well as Genomma Lab Internacional; the Mexican Cultural Institute of New York; the Consulate General of Mexico; AMEXCID; and the New York City Department of Cultural Affairs, in partnership with the City Council.

Finally, we would like to extend our deepest gratitude to Erick Meyenberg for his extraordinary vision and work over the course of several years, as well as to the members of the Banda de Guerra Lobos for their participation, and the numerous collaborators who made this extraordinary video installation and exhibition possible.

Susan Segal, President and CEO, Americas Society/Council of the Americas
Deborah Cullinan, CEO, Yerba Buena Center for the Arts

Osvaldo Sánchez

When One No Longer Is

So I stand, stony, toward
the distance to which I led you.
–Paul Celan

1

I shall not write about the pieces on display assembled under the title *The wheel bears no resemblance to a leg*. Although I'm able to do so, and at another time I could have taken a lot of trouble over it, my interest in the monument has waned. All those festivities touching on and disclosing the exquisiteness of a finished object no longer succeed in engaging or enlisting me. Also, my devotion to proximity, or what I'd prefer to call my meager curatorial accompaniment in the gestation of this experience, is a thing of the past. It was all behind the scenes, barely given voice. I took care to make an unprescribed flow even more dense, mastering a lack of control that revealed itself without intervention, in order to catalyze what was created in the emotive present of an overflowing idleness I shall try to talk about that: the "work" as a continuum of vision, a mobile mirror of the subjects on display, an immaterial certainty of empathy, out of sync with the author's consciousness, confirming the real possibility of implementing sustainable practices in contemporary art, alien to the socialized marketing of the new heroic subjects. Maybe.

2

First came the sound of a trumpet in the dog days of summer. Drumrolls in the stale air of the dirty rooftops. And then came this fixed image from the studio window. The entire proposal was already in this photo: against the light, the little heads formed beneath the awning of the school's rooftop. Barely discernible, those languid bodies took pains to carry out their routine. They walked haltingly, in uniform, brandishing trumpets and drumsticks out of time, burnt by the sun. That vision generated this piece: a vague something about the disciplining of the youthful body, about the *chronos* of the capital, about the available models of offering oneself up, about the transparent mechanisms of submission. It resembled the improvisation of a game without a public, without evident purpose, without tutelage, record, or discipline. Would the gestation of this visualization in progress be the *process of co-participation*?

3

I suspect there is a misunderstanding in the way in which the most frequently used platforms of artistic production—of social commitment, activated in networks and/or collaborative—refer to the idea of process to verify themselves as an alliance of producers in time, which sometimes presumes an initial indifference to the result. And a proclaimed "processual" character would appear to guarantee a redemptive will in the social domain. As if the processes activated in collectives or collectivized in their presentation—delegated performances?—implied in themselves a certain critical energy as an act or produced a certain political articulation in the public domain.

Is what defines an art of "processes" really a reportage in stages, in its productivist exaltation? Isn't the result that this art of "processes"—possibly never exposed to the chaotic effusion of other shared knowledges—ends up being the ideological imposition of an authorial procedure mystified as being collective? Does this "off-studio" gestation, displayed as a production *with a group*, guarantee any civic vitality by breaking away from its terminal space and projecting itself as a production "in the act of becoming," illusorily surviving as the political fruit of a dialogue or (un)expected interchange?

What may be recognized as a *process* cannot simply designate the intellectual continuation of a record of a work's production. Would this record qualify the work as "expanded," processual, solely by the mere in-person overexposure of the subjective reserves summoned to a representation, already museumized, of its own summoning?

In personal terms, for years now, accompanying—*making ourselves* into a process—has been a *sine qua non* curatorial condition and has functioned as a tacit model of heuristics, alien to the category of shared time and the administration of the individual prominence of a stylized experience. What we call "process" here is not the functioning model of an open routine. I understand *The wheel bears no resemblance to a leg* as a situational weave—after almost two years of group contact—capable of always presenting itself as a sudden destiny, in real time, and not as the record of a lengthy agenda of interchanges. *The wheel bears no resemblance to a leg* articulates itself as the proliferation of a lived communitarian (and aesthetic) situation, as metamorphosis of a node of social energy. Here, *being process* is an ever-fragile permanence, a construction of feeling activated by the group's self-revelation. A predisposition to empathy whose ex-temporal presence (I repeat, *ex-temporal*), as a dense encrypting of a human flow, *is* (it continually makes itself transparent as) the piece.

It would be worth the effort not to avoid the slippery slope of a question: What is the spiritual economy—this becoming-accompanied—of each type of practice we classify as "socially committed"?

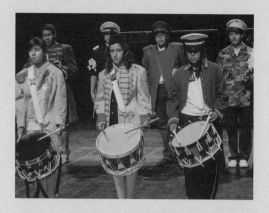

Improvised exercises of visualization, listening, kinesis, and group dialogue were secreted in the course of an entire year's preparations, conceived by Erick Meyenberg and under the curatorial monitoring and coordination of Josefa Ortega.[1] Musicians, choreographers, and costume designers assembled by Meyenberg set in motion conversations, visits, and actions that enabled the dis-alienation of the routine assimilated by this student "band of warriors." First came disobedience to the instrument. Learning to howl. Encountering *"that something in me that only I can offer."* Converting the machine's regulating instrument into an obscure game of chance. Thinking about the memory of a sound, the cracked engobe of a mask, the cynical elitism of every disguise... They visited sound archives, modern museums, costume warehouses. Then came the video sessions: observing the hierarchization of the chief security guard serving the machine; the regulation of choreographed coexistence for the group as a technology of oppression. How to reverse History with the paraphernalia of its own, already-accepted hegemony? How to discredit the ornaments of obedience? How not to applaud the warlike pantomime that makes each body into a premonition of a monument? Over-determine the heroic dramaturgy of the nation-state and drain its blood by means of its own emblems?

1 Once Erick Meyenberg defined the conceptual framework that would guide the process, a session of open critique of the proposal was called; participants included Gerardo Suter, Alexander Apostól, and Héctor Bourge, along with inSite/Casa Gallina's curatorial team.

They improvised on the stage of the Teatro Julio Castillo. Each chose his or her own disguise from the costume storehouses: from the sparkling dress coats of Maximilian's cavalry to the ninja fantasy of the elite military unit Los Halcones [The Hawks]. And then, would they be able to distance themselves from this enthusiasm of school-induced institutional inscription? Would they be able to rearticulate another form of—conscious and fluid—belonging, without the need for a hero, victim, hymn, or flag...? It was necessary to devise little choreographic games that would enable the refusal of the body specific to the State; dismantle pre-existing dynamics of contact, made combustible by the social anxiety of these sons and daughters of families devastated by neoliberal plunder. How would it be for mestizo kids already skilled in the spectacle of consumption and simultaneously dulled by a millennial burden in their self-esteem, the fruit of the systematic racism of their reality, to live the interchange without a mask? How could they—a band of warriors?—read sardonically the pretentious and tattered school uniform, carefully fashioned as a frayed copy of English prep school garb, which reactivated their parents' old fictions of social mobility—so that nationalism could render histrionic the impoverished ceremonies of perpetuation?

5

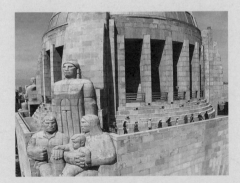

To claw at the site where spilled blood has been forgotten. Choreography, which needs to be precise, is a caricatural model of colonial hegemony. The kids were unaware of this violent history, puncturing the anonymous bodies of other young mestizos decades earlier... Today, 26,659 new *disappeareds* enlarge an invisible monument, without flag or tombstone. The drumrolls

sound. The black tassels sway above the wrinkled shirts. *Left, right, left*. They appear to announce the small transactions between the slippage of the hormonal body and the disciplinary routine that forbids it. The war machine is the motor of this ritual: the inoculation of a disciplinary time. "[To] contain . . . in its mechanical brevity both the technique of command and the morality of obedience."[2] Mexican paraphernalia whose historical pedigree adorns itself in the evidence of *being a race*. The obviousness of how a body incarnates— beyond its impulses—"control of behavior by the system of signals to which one ha[s] to react immediately."[3]

This entire process accompanied the journalistic revelations, the official lies, and the massive protests over the massacre of the 43 students from the Escuela Normal de Ayotzinapa.

And it is not only (again) the State, its historical fictions. This body is also sculpted by TV, marketing, all the morbid accumulative abundance offered by status. Zygmunt Bauman summarizes it nicely: "The success with which the dynamics and values of the market systematically erode the habits of sociality."[4] The narrative of this piece is marked by a reinvention of one's own body. How to destroy the stigma of the body-nation in the subjugated design of the fiction of *mestizaje*?

This process of co-participation promised to unleash a denationalization of the *Masiosare*[5] mestizos and a simultaneous polarization in the economies of self-esteem of the *Brayanes*.[6] Meyenberg induced repeated situations of

2 Michel Foucault, *Discipline and Punish: The Birth of the Prison*, trans. Alan Sheridan (New York: Vintage, 1995), 166.

3 Ibid., 167.

4 Zygmunt Bauman, *Amor líquido* (Mexico City: Fondo de Cultural Económico, 2005), 103.

5 *Masiosares*, from "Masiosare," the "heroic" subject of popular humor, a noun fabricated from the contraction of a phrase from the Mexican national anthem: "but if a foreign enemy should dare [*mas si osare*]/ to profane your soil with its plants." Here, *Masiosare* refers to youths largely identified as mestizos or indigenous people—from the countryside, other states, or extremely poor barrios of the capital—whose only possible future appears to be entering either the army or the police. The term designates the dominant racial profile (and carries a racist denotation) of the low-ranking recruits and people in uniform.

6 *Brayanes* refers to a multitude of young Mexican millennials from low-income families, not only those named "Brian." It functions as a kind of heteronym that identifies urban adolescents born after the North American Free Trade Act whose parents named them after heroes, actors, or protagonists of United States culture, the fruit of the avalanche of entertainment films, junk programming, and TV series promoted by the media in the country's devastated educational horizon.

visualization: producing a distinct perception of one's own body, capable of questioning a subjectivity simultaneously constrained by the expectations of status-symbol consumption and by the sacralization of any normative institutional model. Breaking the kinesis of an inherited domination could perhaps enable them to glimpse the traps of class in which they were ensnared: to choose between becoming the victimizer-instrument that operates the war machine, or opposing it and becoming the blood-victim that sets it aflame. A few of these mestizo kids will surely become recruits, and later perhaps soldiers or police or hired guns of some national or foreign corporation. And those who refuse or struggle against the machine will become statistics, hauled away and burned in a ditch or mutilated in some barren field. Dismantling this ritual of obedience could perhaps help to . . .

The group improvisations began generating corporal images, haptic and kinetic relationships, which demonstrated the collapse of the choreography of power, its simulated integration. There are no white or middle-class people in the national battalions, whose components are the *raza* in uniform, subordinated to the tacit omnipresence of the monument-institution.

At the end, while marking the punishing routines, the kids ended up chanting, counting up to the number 43.

6

Two years dedicated to a work of group collaboration is not a common "production time" these days. The intensive dynamics of symbolic speculation require a "dedication" to a barely conceptual context. There is a predominant

idea that a group's socialization can be produced by a couple of events as if it were an ideological activity. Or that a certain programmatically educational experience with groups could enable the artist to activate a tuning system of a certain density, capable of (self-)generating proto-political networks without getting emotionally involved. Thus, what usually occurs with the a priori of "social commitment" is limiting oneself to performing a mass collaboration—coordinated and pre-produced for the artist by curators and assistants—or recorded as the mini-theater of an enthusiastic and aestheticized group event. Do these authorial platforms of a ready-made, pre-designated social confluence qualify as "committed" actions or as communitarian "empowerment"?

In general, this type of fast-track commitment not only makes evident the tutelary manipulation of the group by the intellectual prominence of a socially benevolent author, but also underestimates the requirement of ALWAYS secreting an emotional fabric, honest and subtle, for the affective constitution of a political situation at the heart—and as the product—of a community of interests and, above all, of a community of governance.

7

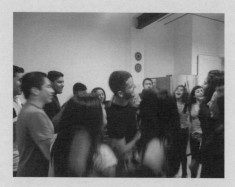

As we know, not all so-called *works of collaborative or co-participatory processes* result in critical platforms permeable to other non-hegemonic models of individual (and group) inscription capable of transgressing the conservative intellectual pedestal of our auratic consecration of contemporary art. Likewise, not all the so-called *works of social commitment* are taken up as a spontaneous gestation in the public domain, capable of revealing/visualizing

the complex negotiation of a situation of collective empathy and (poetic, political) action, nor do they have the modesty of not setting fire to them as a function of personal symbolic capital, as required by the present situation of the market. In these cases, what happens in reality is an extrapolation of social energy. The social is represented as a repertory of "novelty," capitalized and pacified through art. An operation which paradoxically guarantees the depoliticization of other possible living processes, neither simulated nor allegorical, and capable of generating concrete changes from alternative models of sociality.

In the curatorial processes promoted by inSite—and made explicit in *The wheel bears no resemblance to a leg*—what would be recognized as *co-participation* would be the placing in contact of every group experience of knowing—a heuristic condition capable of self-managing a social organism—lived as an implementation of a flow. It implies not only a quasi-annihilation of the authorial subject, but also of the conditioning of language (artistic, intellectual, and socially-ascribed), as orders underpinning the hegemonic system.

The egomaniacal mechanism governing the modes of socialization in capitalism rests on hierarchies and tacit restrictive manuals of class conditioning, which disguise most situations of spiritual simultaneity as "empathic processes," comfortably appropriable by artistic representation—above all in the artistic representations that pretend to have been sparked by "processes" of socialization or to be ingenious or ready-made dramatizations of rituals that articulate docile consensuses. Such "processes," instrumental to a good deal of "socially committed art" (instituted as a will toward commitment within the work), generally mask the political sequestration of another real, proto-political process constitutive of *the public*. Many of these works avoid the slow and meticulous conditions that generate a visualization of the group (as a resultant network), both in the production of its negotiated domain (as a transformative force) and in the production of an explicit social knowledge (the antidote to all entropy) based on the (ludic) experience of daily governance of the very dynamic of the group (as existence contextualized in a *here and now*).

Thus, an art of co-participative processes and of a more complex group/social involvement—exposed to the fragile texture of the public—implies the delicate implementation of an initial disposition of authorial nullification, a model of identitary non-conditioning, alien to the devouring centrality of the modern artistic subject, the perfect accomplice of the hegemonic social

model. Its subtle leadership demands someone capable of inciting a group situation of vulnerable permanence whose indexes of exteriority point toward the design of anon-institutionalized, communitarian belonging in the process of becoming, capable of producing the visualization of a presence-based model of sociality, where we may recognize the "piece" as the result of a network of affections.

8

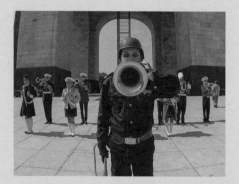

Every process is constituted from an infinity of flows whose primal sources are not always visible and whose drainage estuaries lack a border. Here, such flows are nourished by the small revelations that throughout a year and a half thicken (or not) the group's intersubjective consistency, not only by the sum of individual certainties, but also in full knowledge that the precise record of these contacts and their successive impacts is difficult to track.

Evaluating the real impact of this type of practice surely requires much more than filling out a final questionnaire on the experience lived by the participants. It involves much more than a celebration of the energy of a closing-night party, more than noting a certain liberation of personal narratives spoken out loud: everything that is exalted as a new "outside" at the interior of the group. Also, there is the immanence of what is not said—what cannot be localized, defined, articulated—following the erosion of an experience, in whose drift flows turbulently an always unknown *we-are-other*.

And from the standpoint of the artist, perhaps it would be obligatory for Meyenberg to state where all this led him: in his own creative methodologies and in the subjective and ethical re-configuration of his motivations

and proposals; in what artistic mode may be understood the specificity of a situation in real time and space, a living context whose *materia prima* is now assumed—perhaps forever—to be essentially human.

Then there is all the profusion of opaque external signs, like splinters. The nervousness of the parents seeing the absurdity of these military maneuvers in the barrio's shopping center, their children sounding "lights out" in front of shop windows crammed with ads featuring blond people proclaiming the glory of spending. Or else the flight of drones over the heads of these kids marching on the esplanade of Tlaltelolco in front of the Molino del Rey, where sharpshooters of Operation Galeana and soldiers of the Olympia Battalion machine-gunned students on October 2, 1968. Each situation gave rise to a disturbing sign; for example, the transformation of Toño, the band leader, a young single man with a sick father whose dream was to have more friends and own a bar. Holding a black flag, Toño embodied on his own, and with highly cynical projection, the figure of the henchman, like someone who administers the rhythms of a relational power, the minimum demands of blind compliance and its punishments. Seeing him, the kids could understand that they had to pursue this way of playing differently, without docility, without belonging to the machine. As Rancière suggests: "The real rupture is to stop living in the enemy camp." In the *making off*[7] of the routines, they are phrases and gestures that render this transformation transparent. Perhaps these situations, staged as a kind of *ostrananie* (performative estrangement), subverted through acting, could paradoxically provide them with a more self-critical personal niche from which to resist the colony, racism, and tyranny of capital.

7 *Making off* is an expression that first emerged as a malapropism for "the making of" and is commonly used outside of the United States and other English-speaking countries in the context of filmmaking discussions to refer, for example, to a director's cut which includes commentary from those involved in the making of a film.—Ed.

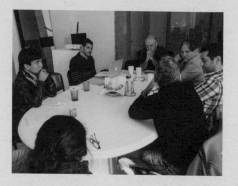

If there is a possible description of the curatorial function as an alternating motor in this process, it would be the dynamic of inciting a web of conversations, visions, and challenges with Meyenberg, which at times functioned as a repertory of mediating narratives within the group, aimed at stabilizing or destabilizing specific situations. An interchange that considered the importance of being alert to the slightest flow: the delicacy of approaching the group; the moments in which the veils of *being increasingly more exposed* were drawn aside, the transgressive nature of every improvisation, the friendly ornaments of coexistence, its scheduling, the occasions when individuals sought to be seen and approached outside the group, the gestures of confidence so that everyone could make certain decisions regarding their image and performative role; how to encourage each participant to trust this risky framework, where one tacitly acts and is eroded as part of a group in the process of becoming. There were also the shared readings, references, quotations, authors, and questions. Discussions on the psychotic nature of visual discourse, editing intensified by syncopes, the staging of a panoptic city (*one's own space of operations*, as Michel de Certeau would say), a more acidic color palette, the fragmented dramaturgy, riddled with culs-de-sac, the psychotic visceral quality of the sound, the transitoriness of certain icons, the coarse quotations from official History; and afterwards... the flags in detail, the possible and impossible alternatives for each display choice. A process of apprenticeship with Meyenberg which became intense, pleasurable, interminable for all. A professional experience which offers the living permanence of this contact is difficult: an itinerary of growth and mutual dedication, where all of us remained exposed, without manipulation or complaint, given over, without starring roles.

10

The gradual construction of meaning inherent to artistic discourse—and whose resulting structure is legitimized as an autonomous language—brings with it, in the becoming of co-participation, the filtration of another construction of (existential) meaning in the experience of its participants. And this other construction of meaning, which is not artistic, is lived as an empathic catharsis of binding consciousness, underlying the collaboration's group-becoming. In every person, the co-participatory process produced a spiritual revelation, a psychological and ethical refocusing, within the communitarian experience. And this could perhaps be its most obvious attribute of social "commitment."

This existential revelation, I suspect, proceeded from the visualization of atypical dynamics of intersubjectivity and sociality: through multiple situations of fusion and contact sublimated by means of aesthetic convention. Co-participation operated as a feedback in flux, between the brain's visual centers and the limbic structures of emotion. A play of mirrors between the ritual intensity of interchanges internalized as a group and the personal psychic exposure, without blockages, of each participant.

Creative experience—predominantly heuristic—flowed on a parallel level of each participant's individual consciousness, over a period of two years. A conscientization of one's own subjectivity which reconceives itself to itself as the confirmation of a still possible I-other—neither constrained nor designed for capital's dispositions, but now re-seen, empowered, and sheltered within the group.

Sometimes, *the wheel bears no resemblance to a leg.*

at the turn
dissenting from any benefit
avid for this breeze without flagpole
exposed to the saliva that designates through contact
the vulnerability of the non-resulted
a fear with you braided in its element
we would be in a situation of penetrating
almost adults, like a brief shining net
always crowned as another
and even so a little bit yours,
and also eroded and yours
being ourselves, being ourselves
when one is
no
longer

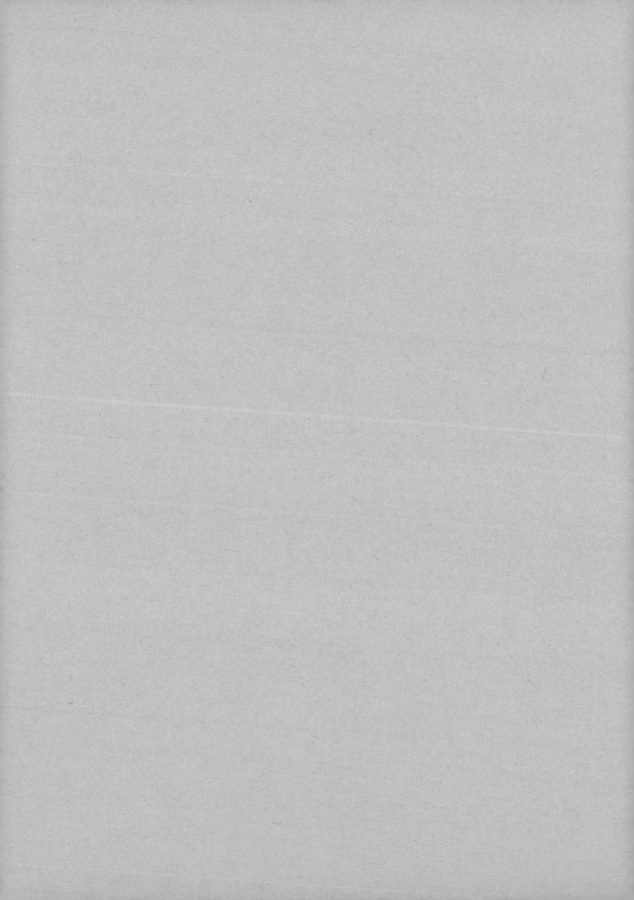

Gabriela Rangel

Surrealist, not Surrealist

. . . my intuition somehow told me that the piece The wheel bears no resemblance to a leg *had to be surrealist . . .*
—Erick Meyenberg

Intuition is the mathematics of God, said one metaphysician, paying no heed to the idea perpetuated by Friedrich Nietzsche that God is dead.[1] It was perhaps this ineffable principle of intuition that sparked the rediscovery by the Mexican artist Erick Meyenberg of the prologue for *Les Mamelles de Tirésias*, a theatrical satire written by Guillaume Apollinaire in 1903 and staged in 1917, the year before his death.[2] Although he may have stumbled upon Apollinaire's text accidentally, it was not arbitrary that Meyenberg chose a fragment from the Franco-Polish poet's little-known work for the title of his *The wheel bears no resemblance to a leg*, a quote[3] he found while searching for historical sources anchored in the mechanomorphic style practiced by Francis Picabia, Marius de Zayas, Marcel Duchamp, and other members of the Parisian avant-garde. Meyenberg's fortuitous encounter with Apollinaire's

1 I am referring to the Venezuelan poet Armando Rojas Guardia in *El Dios de la Intemperie* (Caracas, Editorial Mandorla, 1985).

2 While the play was written earlier, the prologue is dated 1917, the year of its first production. The prologue of *Les Mamelles de Tirésias*, along with a note regarding Jean Cocteau's *Parade* that Apollinaire wrote six weeks before his own play's debut, mark the first mentions and descriptions of the term "surrealism." Guillaume Apollinaire, *Les Mamelles de Tiresias* (Paris, Éditions SIC, 1918).

3 "When man wanted to imitate walking, he created the wheel, which bears no resemblance toa leg. In this way he engaged in surrealism without knowing it." Ibid.

Les Mamelles des Tirésias by Guilliame Apollinaire (Paris, Editions SIC, 1918).
Cover illustration by Serge Férat.

text enabled him to redirect his field of action toward the beginnings of modern European art of the twentieth century in order to complicate the narrative of the composition of a work in gestation. Indeed, the artist usually locates the horizons of his practice in investigation: "Every project has the motive of investigating an 'incident,' which can be a text, a historical period, an event past or present."[4] Nonetheless, possibly the most relevant and productive aspect of evoking the "incident"—the discovery of the Apollinaire quote—may not be rooted precisely in the method or procedure utilized, nor can its best definition be found in the results of said method.

Meyenberg adopts a methodological focus resembling social-scientific models of investigation. His insistence on this focus may be rooted in the desire to maintain artistic autonomy to protect against the speculative flow of capitalist circuits of the knowledge economy.[5] It is worth noting that, for more than two decades, since the art historian Hal Foster identified this

4 Erick Meyenberg in an interview with Daniela Wolf, in Erick Meyenberg, Valerie Smith, and Daniela Wolf, *Labor Berlin 2: Erick Meyenberg: Étude taxonomique et comparative entre les castes de la Nouvelle Espagne et celles du Mexique contemporain* (Berlin: Haus der Kulturen der Welt 2010), 4.

5 In this case, the Banda de Guerra Lobos.

tendency as an essential part of the procedures employed in contemporary art, an oblique, inevitably pendular movement in the aesthetic field has been developing which attempts to rescue artistic practice from both the domination of critics and the rigid hierarchies and specializations of the academy.[6] Paradoxically, this fluctuating movement distrusts investigative procedures and the density of their discursivities, although it proclaims them necessary for embarking upon a pathway, however liquid and elusive, to creation. Meyenberg's projects prior to *The wheel bears no resemblance to a leg* materialized through interdisciplinary and multidisciplinary schemas, in which art served either as an epistemological structure that was methodologically applicable to other areas of knowledge, or as a discourse of origin disrupting the state of being conjugated with the logical operations of other disciplines, rejecting all normativity or protocol attributable to the system of contemporary art. However, Meyenberg's long-term artistic undertakings created between a period living in Berlin and a significant trip to Great Britain taken after he settled in Mexico did not succeed in completely disconnecting him from the frameworks of various archives and methodological resources. The latter frequently collide and explode in his work like meteorites when they make contact with the terrestrial atmosphere, dematerializing into different supports against historical matrices of disciplines such as history, political science, biology, and statistics, as exemplified by his transformation of the letters from prison written by the Marxist theorist and revolutionary Rosa Luxemburg or the *casta* [caste] paintings of New Spain, where he appropriated and intervened on colonial imagery using a variety of color-coded charts, graphs, and statistics to explore ideological constructs such as race.

What remains of the questions posed by Meyenberg when confronting the object of a particular investigation, and where does his persistent inquiry land when recognizing that a stratum of the signified inevitably renders itself elusive for whomever sees or attempts to understand his work? Apollinaire's prologue, for example, contemplates the problem of being the historical carrier of the foundational concept of surrealism. In this sense, adding this substrate to the title "The wheel bears no resemblance to a leg" not only enables the application of a methodology distant from other disciplines

6 See Alejandra Labastida, "Traduttore, traditore! O el tratado del inútil combate," in *El regreso del dinosaurio* (Mexico City: UNAM, 2015).

(literature, theater) and connects a multiplicity of disparate elements in the form of a montage, but it also distances itself from the present, recalling the Benjaminian erosion of the very meaning of the piece through the dispersion of the drawings, sketches, videos, performances, pennants, and collages that materialize through his interaction with a military band from the school located in the Santa María La Ribera district of Mexico City.

It would therefore seem that the central point of Meyenberg's project exceeds the historiographical dimension of the quote extracted from an opaque text of European modernism known only to a very few specialists and which in a way recovers the authorship of the term "surrealism" for Apollinaire, divesting it from André Breton and his ideological apparatus, which incidentally identified Mexico as a surrealist construct. Apollinaire had proposed the term "surrealism" with the goal of dismantling the ontological mechanisms of the naturalist narrative model of the nineteenth century, which was still current at the beginning of the twentieth century, in order to postulate a counter-model that would straddle science and fiction, a kind of super-realism. Apollinaire's formulation of surrealism was modeled on the ethos of the years preceding World War I, when the Paris literary-artistic bohemia was still operating on the margins of society only to pass, during the war years, for an extravagant, original lifestyle that embraced capitalism's quotidian values and economic logic.

Meyenberg's residual recovery of past information would appear reductive if it only amounted to an archaeological use of the first programmatic approach to the foundation of a movement. The relationship of Meyenberg's project to Apollinaire's self-reflexive aesthetic—definitely alien to the avant-gardist doctrinal didacticisms of Breton and the surrealists—is, then, intertextual and obliquely touches on the relationship of *The wheel bears no resemblance to a leg* to the paradigm shift in the abstract representation of modern art attributed to the Nietzschean artist Francis Picabia. In another exploration of the roots of European modernism, Meyenberg appropriated a set of drawings by Picabia, dating from 1913–15, of abstruse and perverse machines in order to develop sketches and banners in tandem with his work with the military band Los Lobos. The engagement with these specific artists is not coincidental, as both Apollinaire and Picabia form two milestones of the European avant-garde, offering exceptional and paradigmatic cases of historical misinterpretation.

Moreover, the appropriation of Apollinaire's quote and Picabia's drawings are two sides of the same coin circulating in the present, a century after the emergence of European avant-gardes, suggesting an effort by Meyenberg to understand and perhaps situate locally subaltern capitalism's various machines (and machinations) that act invisibly in the daily life of the citizens of the Mexican capital, with the purpose of constituting immanent forms implemented on the body of the consumer in the post-NAFTA era. The referential framework of this complex clockwork machinery of the historiography of art, long since stripped of the emancipatory and innovative contents of originary European modernism, is added as a signifier to the invitation extended by the residency inSite/Casa Gallina, whose curatorial organization is formulated within the fixed coordinates of a concrete cultural and geographic context, outlined in the Santa María La Ribera district. If the work proposed by Meyenberg for Casa Gallina was based on an axiological exploration of the pedagogy, disciplinary values, and creativity of the military band comprised of young students—which were all considered in critical relation to the monumental logic of present-day Mexican civility—then the movement from the shopping mall to the Monument to the Revolution and the Plaza de Tlatelolco functioned as a *paideia* of consumption and war made into an image through a performative gesture whose fantastic, Baroque, even carnivalesque—in Mikhail Bakhtin's sense—qualities produced surprise.

I maintain that Meyenberg's poetics inhabits both the ruins and the mold of post-conceptual art's discursive mechanisms: investigation and process. His working method, on the other hand, calls upon that "fundamental dispersion" of which Roger Caillois spoke, and is nourished by an intuition modeled upon and for the elaboration of a "score," composed in the image-making and sound of his creative interaction with other agents, not necessarily creative ones. Here, anarchy tends frequently to manifest itself as a source of imagination and surprise, notions very close to Apollinaire. For Willard Bohn, both concepts—imagination and surprise—laid the foundations for the aesthetic innovation of the Franco-Polish poet in the period from 1914 to 1918, which coincided with the moment in which the machine became central to the work of avant-garde artists who aspired to destroy naturalism.[7]

7 Willard Bohn, "From Surrealism to Surrealism: Apollinaire to Breton," *The Journal of Aesthetics and Art Criticism* 36, no. 2 (1977/78): 197–210.

Returning to the generative origin of Apollinaire's quote, it should be recalled that the short theatrical piece *Les Mamelles de Tiresias* was a text begun by the poet during his youth with the intention of developing a narrative of surprise upon which he elaborated during the last years of his life. Initially, he coined and provided a usable definition for "supernaturalism" (*surnaturalisme*), a sort of exacerbated realism; due to its ambiguity and imprecision, he definitively set "supernaturalism" aside in favor of the neologism "surrealism." Apollinaire's "surrealist drama in two acts written in the style of Aristophanes," features a satiric plot recounting the adventure of Teresa in Zanzibar, a woman whose breasts change into balloons that detach themselves from her torso and explode; Teresa decides to masculinize herself by adopting the name and personality of Tiresias in order to become a professional, refuse to procreate, and reject her husband's authority. Despite the fact that Meyenberg's project did not explicitly or directly consider Apollinaire's plot, the poet's work does inevitably superimpose itself on the peripatetic journeys organized by Meyenberg throughout various public places in Mexico City, featuring adolescent members of the military band Los Lobos, dressed in costumes chosen by them for the occasion from the storehouse of the INBA repertory theater.

Considering Apollinaire along with the poet-critics Max Jacob and André Salmon as protagonists of the aesthetic debate that took place in the Parisian artistic-literary circuit centered in the bohemian neighborhood of Montmartre at the beginning of the twentieth century is a well-trodden path in the study of art history and the early avant-garde. Within this account, Apollinaire's singular, specific program, based on the principles of imagination and surprise as constitutive elements of the modern within the field of artistic creation could, in a twenty-first century dominated by information and technological mediation, be compared to the idea of anarchy as a musical score of silences. In Bohn's words, "If Apollinaire is perhaps thinking of the rash of technological innovations during this period, he is also referring to the precarious nature of everyday reality—as evident in the works of Giorgio de Chirico. If he is alluding to recent cataclysmic political events, he is also referring to the modern distortion of the time-space nexus—as reflected in the cubist paintings of Braque and Picasso."[8] It never ceases to astonish that the

8 Bohn, 200.

monumental, fearsome architecture displayed in de Chirico's paintings was the springboard that motivated Apollinaire's ideas of surprise as a constitutive element of the modern. Meyenberg likewise made use of landmarks of Mexico City's monumental architecture as a metonymy of its immense modern violence.

And it is in this "musical score of silences," an idea conceived by the North American composer John Cage, that Meyenberg's practice is articulated in the manner of a natural right produced by the incalculable atrophy of the notions of time and space in a political economy of surprise: "I'm an anarchist same as you when you are telephoning, turning on/off the lights, drinking water."[9]

9 John Cage, *AnaRchy* (New York: Wesleyan University Press, 1988), vi.

A Conversation between Erick Meyenberg
and Lucía Sanromán

On Transmuted Times

Lucía Sanromán

I associate your previous work with what could simplistically be called "data visualization"—as in, for example, *Étude taxonomique et comparative entre les castes de la Nouvelle Espagne et celles du Mexique contemporain* [A Comparative Taxonomical Study of the Castes of New Spain and Those of Contemporary Mexico, 2010–12]—in which there's a transformation of information coming from various sources, acquired by means of research in multiple disciplines, all of which is then translated to another level of abstraction that does not, in my opinion, seek abstraction for itself, nor even the "direct" expression of the artist's creativity. In this process of translation there's a real "transmutation" (in the sense of a mystical conversion of one chemical or material element into another) of the sources of the work, which isn't just a restructuring of this information into another format. In other words, there's a transmutation from one system of note taking that uses drawing into another that uses sound, for example. This doesn't correspond to an equivalent or one-to-one restructuring, so to speak. On the contrary, the process of transmutation implies several moments of translation such that the final work ends up resembling a sort of musical score in which each line of information or investigation constructs something beyond itself upon being experienced in time and becoming interwoven with the others. This also implies that the work

results not only from the artist's immediate aesthetic decisions, but also from a dialogical process involving a variety of materials and information. Why is it necessary to work in this interwoven way? Is this a critique of the notion of immediate artistic expressivity autonomous from other disciplines, if such a thing even exists?

Erick Meyenberg

In the first place, I think I'm fascinated by the chaos of the real, or by what I perceive as external reality, which pushes me to try to bring order to this chaos. But in the process, I realize that this "order" returns to an organized chaos. So, it becomes, as you put it, a sort of translation of a translation, or a mirror within the mirror itself, in which no matter how much effort I might put into containing, abstracting, and synthesizing order, it always leads to chaos. My projects always begin with an intuitive physical stimulation, and afterward I try to find the reasons why this is motivating me sensorially. Once I'm in the process, which is unconscious and almost automatic, that's when I start doing research and reducing information to more manageable, grasp-able data, because it's impossible for me to leave it in the first intuition of bodily sensations or intellectual motivation. For me all these steps are the way to get that initial sensation out. My aim is for the results to be abstracted or aesthetically organized in a way that feels a bit chaotic and that surpasses or exceeds you or, as in the case of *The wheel bears no resemblance to a leg*, provides an unsettling musical experience that brings me back to the initial mystery. What I don't want, as you say, is to do a one-to-one translation. This is how I've come to understand these phenomena and, once digested, to restore their mysteriousness, or to decode the matrix in order to give another matrix back.

Lucía Sanromán

In the course of these processes, you make countless drawings (almost all of them abstract) and collages, and you also look for artistic precedents, in this case Duchamp and Picabia. You move in and out of the discipline of the visual arts, and you frequently do the work of a composer. This creates the impression of making a "total work of art" in which you fill up the creative space, like water filling up the soil when there's a flood.

Research and process materials, 2014–16. Installation view, Erick Meyenberg: *The wheel bears no resemblance to a leg*, 2016, Yerba Buena Center for the Arts, San Francisco.

Erick Meyenberg

Over the years that I've been following this process—which I could date back to the time I spent in Berlin, when I started using these translation systems—I've realized that producing all this material, like drawings, graphs, sketches, notes, models, objects, and videos, is a tool for understanding the chaos I was telling you about before. But what strikes me as fundamental is that elaborating these materials by hand gives me time to reflect and to concentrate, time I wouldn't have otherwise. What I'm really producing is time— time for the ideas and the aesthetic language of the piece to gestate, time for possible points of communication with other works, time for research—in order to be open to the accidents that happen while working manually, such as when my intuition somehow told me that the piece *The wheel bears no resemblance to a leg* had to be surrealist, and I had a sensation of the machine, and the body, and war, and control. I drove a nail into other, similar sensations I've had, and that's where I find other artists, who could be composers, painters, and sometimes any other personal, autobiographical sensation. It's always in both the drawings of processes and in the fishing around for other artists that I find a sort of way back to a pure, primary, original sensation,

something that's not a literal translation but rather an agency of that pure state shared between the present and the past.

Lucía Sanromán

Since about four years ago or so, you've being doing increasingly complicated and sophisticated video projects, with cinematography, careful editing, and direction, all of which implies a growing skill with the medium. Why did you start using video and what has this medium contributed to your artistic vocabulary?

Erick Meyenberg

I've actually been making videos for many, many years. From a very young age I felt the same fascination that I had at the time with the painted image, but there was a new element: time. Time is there not just because of the movement of the image, but also because of sound. I shot a lot of video back when I was fourteen years old. I never thought that it could be art; I intended to become a painter. It wasn't until I got to Germany that I started to shoot more things and to record the performances I was doing with Rebecca Horn.

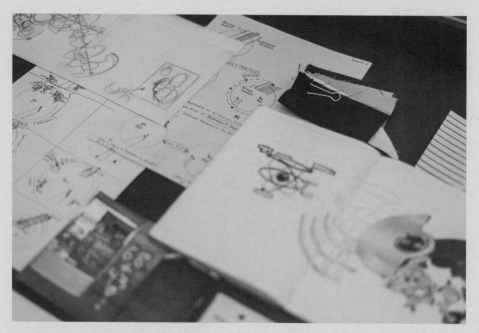

Research and process materials, 2014–16. Installation view, Erick Meyenberg: *The wheel bears no resemblance to a leg*, 2016, Yerba Buena Center for the Arts, San Francisco.

I made some videos in Germany and then I abandoned it. When I came back to Mexico, I realized that video is a fundamental part of what I do. But it wasn't until I was working at inSite/Casa Gallina that I started to make videos with a broader vision, contracting a cinematographer, a sound engineer, audio and video editors, and everything else.

Lucía Sanromán

But in the work there's also another kind of capturing time, which is the real relationship you developed for two years with a group of young people, and with the inSite/Casa Gallina team, which shows the social frame of the work and the dialogical condition of the project. I'm really struck by the modesty and sometimes horror with which the social practice language of participation and engagement are critiqued in Mexico. They're common in the U.S., but in Mexico we think about and do them differently. In this work in particular, as well as in the piece you did for the 2015 Bienal de las Américas and your more recent work for Proyecto Líquido [Liquid Project] in 2016, you're working with individuals or groups who are contributing something important to your work.[1] How do you situate working collectively, and does this process have a political tenor for you?

Erick Meyenberg

With the exception of *Aspirantes* [Aspirants] for Proyecto Líquido, the intention in almost all those pieces was to "co-participate," which for me means that there is clearly a director whose aim is to work with other people, but who is always open to dialogue, to presenting certain ideas, and generating situations that are resolved within an artistic frame. And in this there are always several inevitable social, political, or historical layers or directions. Any situation that exposes the body to creativity and to an architectural space with particular characteristics throws off almost unconscious data that become the material to be worked on by the project, even when the initial intention

1 Consisting of a video-installation and performance executed in collaboration with members of the local Junior Reserve Officer Training Corps (JROTC), Meyenberg created the work, *I Am the Future* for the 2015 Bienal de las Américas in Denver and installed it at the Denver International Airport. For Proyecto Líquido's 2016 iteration, Meyenberg produced *Aspirantes* [Aspirants], a "sound-action" with 130 men that was filmed at the ancient Mesoamerican site of Teotihuacán.

had been to go in the opposite direction. What I've found is precisely the sense of chance involved in working with the real—real bodies with real emotions and intentions other than my own—and this generates a sort of chaos that I've found to be quite advantageous and exciting. I'm surprised by this because I'm quite happy making my drawings, safe inside my studio with my paper and my colors. But this situation of having to compose in space with real emotions and bodies, in imminent moments, has brought something to my work that it needed. And during such processes I've always made the "co-participants" part of these encounters and decision-making processes, especially in the chaos with the kids from Santa María la Ribera, whom I had greater opportunity to get close to and watch mature. As adolescents they were going through a time of change that seems to me to be among the most crucial transitions in a person's life: from being almost children to being young adults with their own decisions to make. This adds something to the work. And I think that if such a level of communication did occur, it's because much of the intention behind the piece—and Osvaldo Sánchez was very important in helping to define this—was to create a space of trust between me and them, and vice versa.

Lucía Sanromán

I've been keeping track of the way Osvaldo Sánchez, the Artistic Director of inSite/Casa Gallina, thinks with respect to the work he calls "co-participation"—which, among other things, distances itself from terms like "participation," "engagement," and "social practice." I regard the work of Casa Gallina as being generative of situations in which there is a mutual, equitable decision—among the advisers and curators at Casa Gallina, the artists, the participants, and the people who live in the neighborhood of Santa María La Ribera—of becoming part of the moment of the "other" in order to break the normative schemata of a society that turns us all into passive consumers. In this process, creating situations that break normative patterns is itself the goal. That is, the aim is not to in Marxist terms "liberate the individual from his or her condition under brutal capitalism," but rather simply to make a space that is syncopated with reality in which other forms and relationships are possible. I'm simplifying, of course. The way you're describing the work of "co-participation" confuses me a bit, because it paints a picture of a kind of fieldwork that strikes me as a bit manipulative or instrumentalized. I'm not sure whether

this is the case because I know you and I know how you work. But the way you're explaining it to me, it sounds like you're using the kids to cultivate more interesting responses or possibilities, in lieu of data or inert objects, and therefore the chance relations created by the responses of living beings enriches your process. But if this characterization is correct, I can't help but conclude that you're definitely getting more out of it than the kids who participated. It's a sort of really bad anthropology. Where's your social responsibility in this project? Or can we even talk about social responsibility in this case because you're simply the author of other people's "experiences"? Do you think that even talking about the project in terms of its ethics distorts its process?

Erick Meyenberg

To start with, I'm not an anthropologist. I don't have pedagogical or anthropological tools to work with society in the most adequate way, nor is my intention an emancipatory one. And as I said, the intention behind this—clearly pushed by the processes at Casa Gallina and Osvaldo's ideas—is to share the experience of what I consider to be life with art and how I live my life and enact my processes. I feel that sharing that is also a social commitment in itself and has a component that is not just about instrumentalizing people in order to achieve my artistic purposes, but rather there's also something that that the kids have gained from this. So, it's not just using people and moving on. But I do maintain that if you're not an anthropologist or a social worker, it's impossible not to occupy the role of director.

Lucía Sanromán

I don't know if it's impossible, because there are other roles in relation to others that we occupy in our lives that don't imply studying groups or individuals and that don't imply just being there to "help," either.

Erick Meyenberg

I don't think these kids are victims of anything, aside from what we're all victims of in Mexico. My intention in working with them was not because I said, "Oh, these poor kids are missing out on a beautiful social reality, I'm going to help them with my art and my perspective." Not at all. On the contrary, I was fascinated by what they were doing from the time I heard them rehearsing from my studio, before working with Casa Gallina. So,

it was the other way around, almost like I was asking them to invite me to collaborate with them.

Lucía Sanromán

You said that you don't believe it's possible not to occupy the role of director in these processes. This seems relevant to me because I've worked with Suzanne Lacy and others who've been fundamental in creating the field of what English speakers call "social practice," or social interaction art, and I would argue that Suzanne is always a director in her participatory projects, particularly the performances that frequently open the processes of workshopping and dialogue, which are her main methods of production, to the public. In my view, she learned how to structure her large-scale performances from film, in the same obsessive way that you do yours. There are two fundamental elements of social interaction art that you have indeed used. One is the role of the finished work of the event or performance in the production process, in this case done for the camera and integrated into public space. And another is the use of the workshop, which is another basic method from social practice. In the workshop, what gets "curated" is the collective process of the art of social interaction, because that's where a real, pedagogical moment of exchange is created.

Erick Meyenberg

As you say, the workshops were the stretch of time when I shared my way of working, my way of seeing things, of doing research, of thinking about history and the future, and also where I looked for the possible activities that we might be able to do together. They were a way of sort of opening up my work process, or of making it transparent and continuing the work process that I follow with my sketches and notebooks. But instead of making graphs, the point was to have experiences with them, for example doing things with acoustic experimentation, like the exercise with collaging images of wolves into the video, which we did in the form of a dialogue, where I edited a video for them so they would understand the language of video. The workshops made us open and vulnerable, and only then did creative ideas start coming from both sides. They were a success because there were several kids who participated and modified the exercises in real time and suggested changes. What we found was fundamental for the performance and editing

of the video. To return to the notion of the director, when suddenly ten of the twenty-five kids began sharing their opinions at the same time, someone had to moderate. Perhaps I was more of a moderator than a director. And that's not an entirely neutral thing, since a director or moderator modulates the situation in accordance with his or her opinion.

Lucía Sanromán

If we regard the workshop as a method of working that has consequences for the work of art, its moments of public interaction were at the Centro Comercial Buenavista, at the Plaza de Tlatelolco, and the Monumento a la Revolución. That's where you did a very precise choreography of their bodies in space in relation to rhythms and to the context and its meanings. And they did this not for a very restricted public from the art world, but rather for the people who normally use the space. Why did you decide to do the performances in those spaces and in relation to those publics?

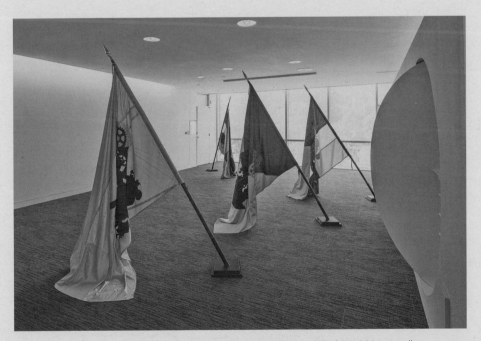

Banderas I–IV (Territorio, Tropa & Orden) [Flags I–IV (Territory, Troops & Order)], 2016. Installation view, *Erick Meyenberg: The wheel bears no resemblance to a leg*, 2016, Yerba Buena Center for the Arts, San Francisco.

Erick Meyenberg

Performances in public space were also extended to actions in other places that aren't shown in the video, such as the Museo del Chopo and the Museo Universitario Arte Contemporáneo (MUAC). The one at the Buenavista shopping mall was the most organized because it was the action that closed the process and gave it meaning. It was the moment when I could join my first intention—that is, the encounter with the kids from the terrace of my studio—with what I felt after having met them, working with them for a year, as well as with the ideas of surrealism, the machine, the distribution and mechanization of bodies in a given space, et cetera. That's why that performance in the shopping mall was more important than the others. I decided to do it there because it's the local hangout for the kids in the Banda de Lobos. It was a decision of theirs that I respected. I didn't love the idea at first, even though the place fascinates me because of how terrifying and awful it is. But most of the kids told me that the mall is where they get together, and it also seemed significant to me because it introduces commercial space into the logic of the project, which adds to the historical spaces that I had chosen. This is one of the chance elements that emerged from the workshops. The decision not to have an art public, or only a small one, was Casa Gallina's, since they wanted to avoid having a specialized public looking at an artistic phenomenon that would introduce the tension of observers who are waiting for something spectacular. In this sense, we went with the logic of the "flash mob." Our goal was to generate a situation for the kids, their friends and relatives, and a few people from the art world. Since I did want to have a record of the action in the shopping mall, I avoided including publics whose body language would indicate that they were waiting for something unusual.

Lucía Sanromán

We haven't touched on musical composition and its relationship to the way the video was edited.

Erick Meyenberg

That process was a bit different, and it changed my whole approach to the experience of collaboration. It revealed video not only as a form of documentation but also as an entity unto itself that would digest and discharge a product that was independent of the performance, in its own language of

the moving image with sound. This process happened naturally, in response to what the work was asking of us—it was like the material yelled out what it needed. The first cuts were completely documentary, and I quickly realized that there was no way of approaching the lived material by means of the document. Instead, there had to be one more translation, appealing to the primary sensation of when I encountered the kids in that urban Mexican landscape with that very particular sound of Mexico City, plus the martial music that the kids were playing before I met them, and what happened in my body by synesthetically conjoining all these sensations. In the end, we wagered on creating a much more organic musical base that has to do with the title of the piece. Let's say that the organic base is the leg, the human body. I worked on this with the sound engineer, intervening in all the recordings we did with the kids, extending them in time, cutting out frequencies, modifying their heights, cooling them down, adding sound to them to create a first acoustic base that would lend all the affection to the piece. Above all, it needed two more elements, as I described them to Alejandro Castaños, the composer: first, the voice of the machine, more melodic and sing-able, made from chords that become more and more present until they combine with the martial music, and that's when we hear a breaking point; and second was a moment of improvisation and noise that would musically bring together what Alejandro had done in the score with what Félix Blume, the sound engineer, had worked on in the organic part. There was creaking, pizzicato, striking on the body of the viola, between the groaning of the body and the clanking of the machine, an intermediate language. The piece was composed of these three acoustic elements.

Lucía Sanromán
Let's say then that the process of co-participation also extends to your work with people who, in a different model of cinematic work, would be directed in a more controlled way.

Erick Meyenberg
Think of a musical score à la John Cage, in which there are all the instructions, but they're open to improvisation. Despite everything being measured for the performance—the tempos, the stairs, the steps, the directions of movement—there were moments open to the interpretation of the band director

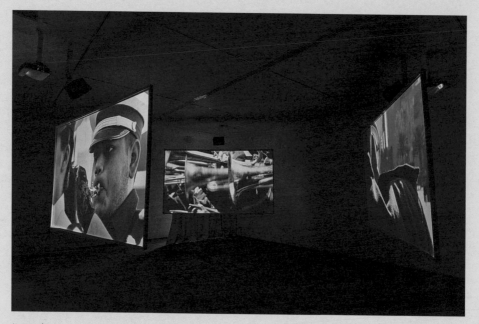

La rueda no se parece a una pierna [The wheel bears no resemblance to a leg], 2016. Installation view, *Erick Meyenberg: The wheel bears no resemblance to a leg*, 2016, Yerba Buena Center for the Arts, San Francisco.

and the kids. The video on the LED monitors around the shopping center functioned as the director, giving the instructions to walk and change the rhythm or move on to the next part of the choreography. And the kids knew that when a certain image appeared they had a certain number of minutes to improvise. Any delay in acting in response to the images would eventually create chaos, which is what ended up happening. But what seems to me to be marvelous is that once "the machine" appeared—and by "machine" I mean the kids doing the performance in the shopping center—there was an element of error that was resolved when they started making decisions within the same logic, and swallowed that error, putting the tempo back together in order to get back into mechanical synchronization with what we had planned.

Lucía Sanromán

This leads us to the metaphor that guides the project: the social, military, psychological machine that makes us act in a mechanical way, and functions as the metaphor for a system that corrects us to the point of modeling us within its schemata, making us docile and generating only certain kinds of desires.

We could argue, however, that the functional metaphor of the twenty-first century is no longer the machine, but the network, which has other properties. The metaphor of the machine has modernist but not properly postmodernist connotations, as the cybernetic being does.

Erick Meyenberg

It was always very present at an unconscious level because of the martial band and the functioning of the body within a military discipline. I saw how separate organisms, upon being submitted to a collective ordering, functioned as a single organism and how that organism carried out a joint activity to achieve its objective. This was something that was latent from the beginning, but the idea of the machine emerged toward the end of the action in the shopping mall, when I decided that the piece had to have a surrealist character. Everything I had gone through with the project was evoking in me something that was familiar; what was immanent to the process was the surrealist notion of dread toward the machine, a machine that not only fascinates you because it helps you to progress in work, but also, in the early twentieth century, turns into something that can kill you. In this project the machine that kills you is not on the outside, but rather has been inoculated into bodies themselves. And now with what you're saying about networks, it seems unsettling because the machine is no longer made of cogs and ironworks, which bring with them a modernist nostalgia; what's in charge now is the very thought of the machine, not its mechanics. The intent behind the piece has been to let the thought of the system be seen without unveiling the system itself. Hence the idea of arranging the screens (at Americas Society) into a sort of panopticon, and for these to be slightly above eye level. It's a subtle gesture of submitting the spectator's body to the experience of being immersed in the video.

Lucía Sanromán

Especially since the screens at Yerba Buena Center for the Arts [YBCA] are quite big, and it's a somewhat oppressive experience. The piece was being produced at the time when we were getting news of the disappearance of the forty-three students in Ayotzinapa. As you know, the news had a profoundly negative effect on me; I was practically debilitated. And you were starting to read Proust, even though at the time I didn't know you were working with adolescents for Casa Gallina/inSite. It was a very personally and socially

difficult moment, with a very strong feeling of mourning and rage, with weekly protests that went on for months. At the YBCA exhibition, you take a quote from Paul Celan that pays homage to the Jews who were murdered in Nazi concentration camps: "Cavamos una fosa en los aires no se yace allí estrecho [We dig a grave in the breezes there one lies unconfined]." Those bodies, too, disappeared into thin air. I'd like to know more about the political connotations of the piece. Do you see it from a denunciation standpoint? How does it function in relation to the political?

Erick Meyenberg

The explicit intent behind the piece isn't to express a political denunciation, but it does so all the same. My own understanding of my work has changed radically in that I think that to get at something truly political, one first has to touch bodies and activate them at the level of sensation, without appealing to a priori political ideas. And something that becomes effective in terms of political critique is that there's a real involvement and a real expressivity of bodies. I don't have to say anything for adolescents' bodies to make evident all these conditions of order and control, using military discipline and order—which is really a game for them, making it more perverse. I think this is more political than literally denouncing the disappearance of the students in Ayotzinapa would have been. We did, however, do a couple of exercises and meetings with them that expressed the unclassifiable quality of the political moment through which we were living. At one of their rehearsals, I saw the teacher punish them by using the instruments as weights while doing squats and counting the forced exercises. It was impossible not to equate this with the marches where people counted from one to forty-three, yelling out for "justice" at the end. And if, on top of this, we add the bodies of young people being submitted to military discipline, it was impossible not to draw relationships and not to make these young people speak for the ones who had been disappeared, and for these, too, not to refer to the other young people who had been murdered at Tlatelolco in 1968. Celan's *Todesfuge* [Death Fugue] is the most political, historical, and powerful poem I know, and it narrates through images that "disappear into thin air," which is one of humankind's most tragic events. I put it in relation to the exhibition to contextualize the found objects of the director's hat and cornet. This phrase directs the objects toward a poetic image that surpasses all limits of the logical

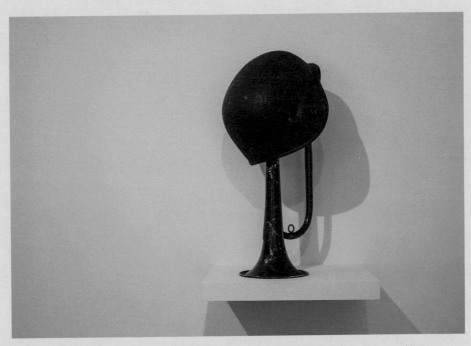

Cavamos una fosa [We dig a grave], 2016. Installation view, *Erick Meyenberg: The wheel bears no resemblance to a leg*, 2016, Yerba Buena Center for the Arts, San Francisco.

comprehension of things. Paul Celan chose that title because he composed the poem like a baroque fugue, which he did because of this perverse thing to which some of the victims were submitted: while some of them were digging graves, others were made to play music and dance. The poem always follows the rhythm of the language of this fugue: while some are dancing, others are digging, others are playing, and others are dying, others are going to their graves in the sky. It's also a portent of what you'll find in the video.

ARTIST'S BIOGRAPHY

Erick Meyenberg (b. 1980, Mexico City) is a multimedia and interdisciplinary artist who works at the interstices of drawing, collage, video, performance, and sound. Both borrowing and extrapolating from methodologies rooted in the natural and social sciences, Meyenberg combines data and aesthetics in his exploration of the hidden aspects of contemporary reality, problematizing such concepts as identity, history, gender, race, and modernism.

From 2005 to 2009, Meyenberg studied visual arts at the National School of Fine Arts (ENAP) in Mexico City, and later earned his MFA from the Berlin University of Arts (UdK), where he worked as guest student under the guidance of German artist Rebecca Horn. In 2011, he received the honorable mention Centennial Award at ZONA MACO, and in 2015 his video-installation and performance piece, *I Am the Future*, was commissioned by the Bienal de las Américas in Denver, and installed at the Denver International Airport. Works by Meyenberg are included in such public collections as the Museo Universitario Arte Contemporáneo (MUAC) at the Universidad Nacional Autónoma de México; Fondazione Benetton, Milan and Rome; and Fundación Telefónica, Mexico.

Meyenberg has participated in numerous group shows throughout Europe, the United States, Canada, and Mexico. His solo exhibitions include: *Labor Berlin 2: Erick Meyenberg. Etude taxonomique-comparative entre les castes de la Nouvelle Espagne et celles du Mexique contemporain* [A Comparative Taxonomical Study of the Castes of New Spain and Those of Contemporary Mexico], Haus der Kulturen der Welt, Berlin (2010); *Back to the Present*, Arróniz Arte Contemporáneo, Mexico City (2011), *Das ist kein Fleisch* [That is Not Flesh], International Festival of Lights (FILUX), Laboratorio de Arte Alameda, Mexico City (2013); *El regreso del dinosaurio* [The Return of the Dinosaur], Museo Universitario del Chopo, Mexico City (2014); and *Un Futuro Anterior* [An Anterior Future], Laboratorio Arte Alameda, Mexico City and *Aspirantes* [Aspirants] for Proyecto Líquido, Mexico City (2016). In 2015 he was invited to participate in the arts residency inSite/Casa Gallina, the sixth edition of the public art project inSite. There, he developed the project *La rueda no parece a una pierna* [The wheel bears no resemblance to a leg], on view at Yerba Buena Center for the Arts, San Francisco, and Americas Society, New York in 2016–17, as Meyenberg's first solo presentation in the United States.

CONTRIBUTORS

Gabriela Rangel is Visual Arts Director and Chief Curator at Americas Society. She worked at the Museo Alejandro Otero in Caracas, Venezuela, and the Museum of Fine Arts, Houston. She has curated and co-curated numerous exhibitions on modern and contemporary art focusing on such artists as Carlos Cruz-Diez, Gordon Matta Clark, Arturo Herrera, and Alejandro Xul Solar. She has also contributed to the art periodicals *Art in America*, *Parkett*, and *Art Nexus*. Rangel has edited numerous books and has contributed texts to such publications as *Abraham Cruzvillegas*, *Empty Lot* (Tate, 2015), *Marta Minujín* (Ciudad de Buenos Aires, 2015), *Javier Téllez/ Vasco Araujo, Larger than Life* (Fundacao Calouste Gulbenkian, 2012), and *A Principality of its Own* (Americas Society-Harvard University Press, 2006).

Osvaldo Sánchez is a curator and writer based in Mexico City. He was the founding art columnist of *Reforma*, the major Mexico City newspaper (1994–96) and also served as Director of the IV and V International Forums of Contemporary Art Theory (FITAC, 1994–95). In 1999, Sánchez co-founded the Patronato de Arte Contemporáneo in Mexico. He was Artistic Director for the public art project inSITE_05 and also served as co-curator of inSITE 2000–2001. Between 1997 and 2007, he was Director of the Museo de Arte Moderno, the Museo Tamayo Arte Contemporáneo and the Museo de Arte Carrillo Gil in Mexico City. Since 2013, he has been Artistic Director of inSite/ Casa Gallina.

Lucia Sanromán is a Mexican curator. Since 2015 she has served as Director of Visual Arts at Yerba Buena Center for the Arts in San Francisco. In 2015, Sanromán worked on *Playgrounds for Useful Knowledge*, a collaboration with Philadelphia Mural Arts and Cohabitation Strategies. In 2014, she was co-curator of SITE Santa Fe's signature Biennial *SITElines.2014: Unsettled Landscapes*. That same year, she presented *Citizen Culture: Art and Architecture Shape Policy* at the Santa Monica Museum of Art, and curated the retrospective exhibition *inSite: Cuatro ensayos de lo público, sobre otro escenario*, at Proyecto Siqueiros: La Tallera, in Cuernavaca, Mexico. She was Associate Curator at the Museum of Contemporary Art San Diego from 2006 to 2011.

YERBA BUENA CENTER FOR THE ARTS

Yerba Buena Center for the Arts (YBCA) is one of the nation's most innovative contemporary arts centers. Founded in 1993, YBCA's mission is to generate culture that moves people. Through powerful art experiences, thoughtful and provocative content, and deep opportunities for participation, YBCA is committed to creating an inclusive culture that awakens personal and societal transformation. YBCA presents a wide variety of programming year-round, including performing arts, visual arts, film/video and civic engagement. For tickets and information, call 415.978.ARTS (2787).

LEADERSHIP
Deborah Cullinan, Chief Executive Officer
Marc Bamuthi Joseph, Chief of Program
 and Pedagogy
Jennifer Martindale, Chief of Marketing
Jonathan Moscone, Chief of Civic
 Engagement
Scott Rowitz, Chief Operating Officer
Charles Ward, Chief Development Officer

BOARD
Paul Connelly, Board Chair
Rekha Patel, Vice President and Finance
 Co-Chairperson
Erik Mayo, Treasurer and Finance
 Co-Chairperson
Berit Ashla, Secretary
Diana Cohn, Member-at-Large
Helen Sause, Emeritus
Peter Bransten
Jeff Chang
Amy Eliot
Elna Hall, PhD
Meklit Hadero
Kevin King

D.J. Kurtze
Jocelyn Lamm Startz
Laura Livoti
Mark Miles
Sabrina Riddle
Catalina Ruiz-Healy
Paul Ryder
Diane Sanchez
Vicki Shipkowitz
Meg Spriggs
Marc Vogl
Vinitha Watson
Karen Wickre
Zak Williams
Johann Zimmern

VISUAL ARTS DEPARTMENT
Lucía Sanromán, Director of Visual Arts
John Foster Cartwright, Senior Preparator
Dorothy Dávila, Associate Director of
 Visual Arts
Tesar Freeman, Chief Preparator
Susie Kantor, Curatorial Associate
Elena Morrison Lyman, Graphics
 Production Designer
Katya Min, Curator of Public Programs
Rebecca Silberman, Registrar
Martin Strickland, Exhibitions Associate,
 Registration and Production

Yerba Buena Center for the Arts
701 Mission Street
San Francisco, CA 94103
415-978-ARTS
ybca.org

CREDITS

This publication was produced in conjunction with the exhibition *Erick Meyenberg: The wheel bears no resemblance to a leg.* Curated by Gabriela Rangel and Lucia Sanramón, the show was on view at Yerba Buena Center for the Arts from October 14, 2016 to February 19, 2017, and at Americas Society Art Gallery from May 3 to July 22, 2017.

The video piece *La rueda no se parece a una pierna* was commissioned by inSite/ Casa Gallina 2014–16, and curated by Osvaldo Sánchez and Josefa Ortega. The project was made possible through the generous support of Cámara de Diputados (México), Secretaría de Cultura (México), and Fundación Jumex Arte Contemporáneo.

At YBCA the exhibition was made possible through the generous support of the Panta Rhea Foundation, the Consulate General of Mexico in San Francisco and the Mexican Agency for International Development Cooperation. YBCA Exhibitions 2016–17 are made possible, in part, by Mike Wilkins and Sheila Duignan, Meridee Moore and Kevin King, and the Creative Ventures Council. YBCA Programs 2016–17 are made possible, in part, by The James Irvine Foundation. Additional Funding for YBCA Programs 2016–17: National Endowment for the Arts, Adobe, Abundance Foundation, Gaia Fund, Grosvenor, and members of Yerba Buena Center for the Arts. Free First Tuesdays underwritten by Directors Forum Members.

Yerba Buena Center for the Arts is grateful to the City of San Francisco for its ongoing support.

At Americas Society the exhibition was made possible by the generous support of the Panta Rhea Foundation, Genomma Lab Internacional, and Mex-Am Cultural Foundation. This program was also supported, in part, by public funds from the New York City Department of Cultural Affairs, in partnership with the City Council. Additional support comes from AMEXCID, the Consulate General of Mexico, the Mexican Cultural Institute of New York, and the Rockefeller Brothers Fund.

ACKNOWLEDGMENTS

The artist wishes to thank the following, without whom this project would not have been possible: Alexander Apóstol, Ander Azpiri, Héctor Bourges, Abraham Cababie, Lidia Camacho, Muna Cann, Graciela de la Torre, Arturo Delgado Fuentes, Daniel Garza Usabiaga, Gabriel Heads, Gerardo Hernández, Pamela Horita, Jorge Jiménez Rentería, Héctor López, Juan Meliá, José Luis Paredes, Horacio Peña Flores, Antonio Pérez Tapia and the Banda de Guerra Lobos. Naomi Rincón Gallardo, Francisco Javier Rivas Mesa, Josefa Ortega, Julien Salabelle, Osvaldo Sánchez, Susana Solis, Gerardo Suter, Jorge Vargas, Karina Vargas, Bodega de vestuario de la Coordinación Nacional de Teatro del INBA, Centro Cultural del Bosque, Centro Cultural Universitario Tlatelolco, Colegio Hispanoamericano, Digital Dreams, Fonoteca Nacional, Grupo GICSA/Plaza FORUM, Museo Universitario Arte Contemporáneo and the Museo Universitario del Chopo.

The editors wish to thank the following people for their generous collaboration:

Ing. Salvador Álvarez Hoth
The Buenaventura Collection
Diana Cohn
Mónica de la Torre
Francisco Goldman
Diego Gómez Pickering
Michael Krichman
Anna Indych-López
Hans Schoepflin
Caterina Toscano Gómez-Robledo

The wheel bears no resemblance to a leg
©2017, Americas Society
©2017, Yerba Buena Center for the Arts

EDITORS
Karen Marta
Gabriela Rangel
Lucía Sanromán

MANAGING EDITOR
Susanna V. Temkin

ASSOCIATE EDITOR
Tommaso Speretta

COPY EDITOR
Melina Kervandjian

TRANSLATORS
Christopher Leland Winks
Christopher Fraga

BOOK DESIGNER
Cristina Paoli · Periferia

First published by
Americas Society
680 Park Avenue
New York, NY 10065

Yerba Buena Center for the Arts
701 Mission Street
San Francisco, CA 94103

All texts © 2017 the authors
Unless otherwise noted, all artworks
© Erick Meyenberg
Other artworks © see photocredits

Printed and bound by Artes Gráficas Palermo, Madrid, Spain

ISBN 978-1-879128-42-2